IMAGES of America
CHAVES COUNTY

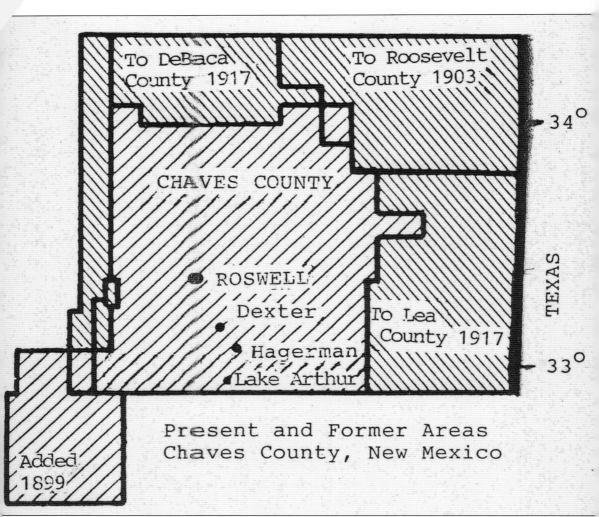

Shown in the map drawn by Elvis E. Fleming above is all of the land currently and formerly occupied by Chaves County, New Mexico. The area with lines running down to the left encompasses the current area occupied by the county, and the lines down to the right show land that used to belong to Chaves County and that was annexed to neighboring counties. The seat of Chaves County is Roswell, and to the south of Roswell are Dexter, Hagerman, and Lake Arthur, all small towns with populations at or around 1,000 people. (Courtesy Historical Society for Southeast New Mexico [HSSNM].)

ON THE COVER: A group of apple pickers from the J. J. Hagerman Ranch, formerly John Chisum's South Spring River Ranch south of Roswell, pose for this 1910 photograph. At 500 acres, the Hagerman Orchard was speculated by Chaves County residents at the time to be the biggest apple orchard in the world. (Courtesy HSSNM, No. 3424.)

IMAGES of America
CHAVES COUNTY

John LeMay and the
Historical Society for Southeast New Mexico

Copyright © 2009 by John LeMay and the Historical Society for Southeast New Mexico
ISBN 978-0-7385-7850-7

Published by Arcadia Publishing
Charleston SC, Chicago IL, Portsmouth NH, San Francisco CA

Printed in the United States of America

Library of Congress Control Number: 2009926444

For all general information contact Arcadia Publishing at:
Telephone 843-853-2070
Fax 843-853-0044
E-mail sales@arcadiapublishing.com
For customer service and orders:
Toll-Free 1-888-313-2665

Visit us on the Internet at www.arcadiapublishing.com

For Elvis E. Fleming, who has been long overdue for a book dedication, and Walter S. Dollahon, who left us much too soon.

Contents

Acknowledgments		6
Introduction		7
1.	Early Settlements	9
2.	The Creation of Chaves County	19
3.	Dexter, Hagerman, and Lake Arthur	37
4.	Rural Roswell	65
5.	Lower Peñasco and Elk	79
6.	Pearl of the Pecos	87
7.	Ghost Towns of Chaves County	111
8.	The Historical Society for Southeast New Mexico	123
Bibliography		126
Index		127

Acknowledgments

First off, I would like to thank all of the people in Roswell and Southeast New Mexico who made my previous book for Arcadia Publishing, *Roswell*, a success and inspired this sequel in cooperation with the Historical Society for Southeast New Mexico, without whom this book certainly would not have been possible. For agreeing to coauthor this book, I'd like to thank the Historical Society for Southeast New Mexico, its board of directors, Pres. Ron Higginbotham, Vice Pres. Charles Butler, Secretary Jean Maley, Treasurer Joyce Ware, Elaine Mayfield, Richard Lucero, Jerry Brown, John Carter, Rick Scifres, Owanda Davis, Tom Weathers, Lana Boswell, museum director Roger Burnett, and the administrative director of the Historical Foundation for Southeast New Mexico, Bella Romain. And as always, I would like to extend another big thank you to the irreplaceable Elvis E. Fleming—a walking encyclopedia on all things Southeast New Mexico—for proofreading this manuscript and clearing up the usual historical conundrums. I would also like to thank my girls at the archives, Peggy Stokes and Katie Galassini, for always being so pleasant to work with and keeping things interesting at the archives building. A big thank you also goes out to Dean Wilkey and Stephen Hussman of New Mexico State University Library Archives and Special Collections in Las Cruces for allowing us to use several pictures of Elk, New Mexico. I would also like to thank, once again, Jared Jackson—the coolest editor I imagine I will ever have—for his help in getting this book off of the ground. All of the images in this book, including those of the Larkham Albums, unless noted otherwise, belong to the Historical Society for Southeast New Mexico (HSSNM) and are listed with their respective archival collection numbers.

INTRODUCTION

In the early parts of 1889, three men with petitions from the people of Lincoln County, New Mexico, journeyed to the Territorial Council and House in Santa Fe to request the creation of two new counties, to be carved out of massive Lincoln County—the largest territory in the United States at the time. The three men were former Civil War captain Joseph C. Lea, former lawman Pat Garrett (who had killed outlaw Billy the Kid only eight years earlier), and New Mexico land developer Charles B. Eddy of Eddy, New Mexico (now Carlsbad).

The three men proposed that due to the size of their respective towns (Roswell and Eddy) and the distance between those towns and the county seat in Lincoln, two new counties could be created with Roswell as the seat of one county and Eddy the seat of the other.

The bill creating Chaves and Eddy Counties was passed on February 25, 1889, and from then on, both counties experienced considerable growth. In the next 10 years, Roswell grew to a population of several thousand people, and three new towns—Hagerman, Dexter, and Lake Arthur—were created as well. Chaves County and the towns in its jurisdiction largely owe their creation to the people of Roswell and their discoveries and achievements, namely artesian water and the coming of the railroad.

"Roswell, New Mexico, had its origins in the New Mexico Indian problem and the Texas cattle trade. The two were closely related in this region," wrote James D. Shinkle in his landmark book *Fifty Years of Roswell History 1867–1917*, published in 1964. This is basically true, for without the problem of Native American raids across the state, Bosque Redondo, the reservation at Fort Sumner, would never have been created. Had Bosque Redondo never been created, there would have been no need for the large amounts of Texas beef needed to feed all of the Native Americans at the reservation. Without that, there would have been no Goodnight-Loving Cattle Trail blazed from Texas to Fort Sumner, New Mexico, and without that, there would have been no Roswell.

Like many places, Roswell started out as a barren piece of land. Eventually an entrepreneurial individual built a small trading post, which grew into a general store and post office, garnered its own name and township, enticed settlers and many head of cattle into the general vicinity, and grew into a city with a population of over 50,000 people more than 100 years later. That is Roswell's history in a nutshell. Roswell began as mere 15-foot-by-15-foot adobe trading post built by an individual named James Patterson along the Goodnight-Loving Cattle Trail around 1867. With its flowing streams of water and grassy prairie, the Pecos Valley, in which Roswell was situated, was an ideal spot for many Texas cattle drivers to stop to water and feed their cattle.

In the late 1860s, New England–born Van C. Smith came along and bought the post, as well as a good number of horses and cattle, from Patterson and expanded it to become a hotel/restaurant/casino. Next to it he also built a general store. At first, Roswell was not known as Roswell at all, but as Rio Hondo, a small Hispanic settlement in the area of Smith's two buildings. (Rio Hondo, today called Chihuahuita, survived as its own community in Roswell.)

In 1872, Smith decided to call his place Roswell after his father, Roswell Smith of Nebraska. Smith also petitioned for his settlement to become a post office, and so it was in 1873 along a "Star Mail Route" between Las Vegas and La Mesilla. Roswell was not just the site of a post office though. Thanks to Smith's infamous gambling habits, Roswell was a notorious place to visit in the territory. Author Lilly Klasner, in her work *My Girlhood Among Outlaws*, gives the impression that Roswell was not a place for respectable folks to visit back in its early days.

After completing his general store, Smith's first order of business was to build not one but two parallel half-mile race tracks in Roswell. He even built a judges' stand and went east to get racehorses for his tracks, but the fun didn't stop with horse races. Smith also put on cock fights as well as dog fights, not to mention the seemingly endless card games, often lasting late into the night. People came from all over to take part in the betting, from Santa Fe to Albuquerque and even from other states. However, Smith's gambling habits often caused him to neglect his small settlement and to eventually lose it altogether, for when no cattle herds passed through, or more importantly, there were no fellow gamblers to fraternize with, Smith high-tailed it to Santa Fe, Las Vegas, or Albuquerque for some excitement.

Roswell's biggest stake in the lore of the Old West comes in the form of legendary cattle baron John S. Chisum, one of—if not the—wealthiest cattlemen in the Southwest. (Chisum was even portrayed by the Duke himself, John Wayne, in the title role of *Chisum*). Chisum too came to Roswell via the Goodnight-Loving Cattle Trail and was, for a brief time, a partner of Charles Goodnight. Chisum bought some property north of Roswell, then called the Bosque Grande, where he set up headquarters for a time. Chisum made the Roswell area his permanent home when he moved from the Bosque Grande headquarters to land south of Spring River, thus creating South Spring River Ranch.

As stated earlier, before the creation of Chaves County in 1889, Roswell was part of the wild and lawless Lincoln County, the largest territory in New Mexico as well as the United States. Roswell came into its own during the turbulent late 1870s of the Lincoln County War, in which opposing sides fought over land and government beef contracts. Thanks to Roswell's stable leader, Capt. Joseph C. Lea, a Civil War veteran who arrived there in 1877, the town managed to stay mostly neutral. Before the arrival of Lea, cattle baron John Chisum had looked over the town to an extent after Van C. Smith's departure in 1875. To keep the town from falling into the hands of the Santa Fe Ring's leader, the notorious Thomas B. Catron, during the start of the war, Chisum urged fellow cattle baron Marion C. Turner (ironically on the other side of the war from Chisum) to file on the land for $800 under the Preemption Act of 1841. Had Catron kept the Roswell land, Roswell would not have been a neutral and peaceful place to be during the war and may not have flourished at all.

After the bloodshed of the war was finally over in the early 1880s, many settlers began arriving in the Roswell area and starting their own ranches and farms. Today Roswell, along with Dexter, Hagerman, and Lake Arthur, is known as the Dairy Capital of the Southwest.

One

Early Settlements

Southeastern New Mexico is one of the rare places in the state to not have been thoroughly explored by the conquistadors when they first arrived on the North American continent in the 16th century. The lone exceptions, who briefly passed through this part of the state while traveling up the Rio Pecos, were Antonio de Espejo in 1582 and Gaspar Castano de Sosa in 1590. Aside from them, there are also a few petroglyphs depicting a man on a horse, believed to be a conquistador, carved by Native Americans in present-day Bottomless Lakes State Park near Roswell.

Southeastern New Mexico did have Native Americans though—the Mescalero Apaches and before them the Jornada Mogollon people. The existence of the Jornada Mogollon people is known thanks to an archaeological dig done in 1990 outside Roswell during the construction of a highway bypass. Found at the site was a pit-house village occupied by the Jornada Mogollon people from 1250 to around 1425.

During the period of Western exploration, when New Mexico became a territory of the United States, the Mescalero Apaches proved to be a huge thorn in the side of new settlers, particularly cattle baron John Chisum. One story goes that after suffering an especially bad raid by the Mescalero Apaches, Chisum followed them to Fort Stanton and lead an assault on them. He did so by supplying the soldiers there with enough liquor to get falling-down drunk. Then Chisum proceeded to raid the Mescalero village, possibly killing as many as 150 Apaches, although the story's authenticity is still debated today. Either way, from then on, it is said the Native Americans no longer raided Chisum's herds and referred to Chisum and his men as "The Big Hats."

As for non-natives, before Roswell was ever built there was first Rio Hondo, a Hispanic community that later grew into what is now known as Chihuahuita on the east side of Roswell. Also near Roswell were two other settlements, Rio Berrendo and Missouri Plaza, neither of which lasted long.

Shown here are some remains of Missouri Plaza, one of Chaves County's earliest settlements. Missouri Plaza was founded by several Mexican American families as well as a few Anglos. Historians speculate these people had been freighters on the Santa Fe Trail on their way to Missouri, so they called their small settlement near the Rio Hondo, close to the current-day site of Roswell, "La Plaza de Missouri." In the *c.* 1934 image to the left are the remains of the North Bridge at Missouri Plaza, and below is an old dam. Missouri Plaza was abandoned in the early 1870s, when upstream irrigation in the Rio Hondo dried up. (Both courtesy HSSNM: left, No. 1493D; below, No. 1493F.)

Pictured above and below are two of the earliest known photographs of the Hispanic Roswell community today known as Chihuahuita, or "little Chihuahua," after the Mexican state of the same name. It began life as one of the earliest Roswell settlements, Rio Hondo, although it outlasted all of the others, like Missouri Plaza and Rio Berrendo. Rio Hondo predated these other settlements and was colonized in the 1850s by Hispanics from Mexico, Northern New Mexico, and Texas. Chihuahuita also grew and developed independently of Roswell, even though it was later incorporated into the city limits. (Both courtesy HSSNM: above, No. 159C; below, No. 159D.)

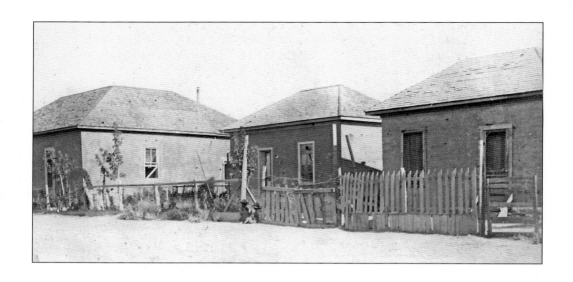

Some of the homes and suburbs of Chihuahuita are pictured in the two photographs on this page. The homes in Chihuahuita are the oldest in Roswell and are located near the Hondo River (which is why Chihuahuita was originally called Rio Hondo) on the east side of town. Almost all of these early homes are built out of adobe with pitched roofs in the New Mexico vernacular style. Today the Chihuahuita neighborhood has its own barbershops, schools, laundries, markets, churches, and so forth, and is still its own individual community in a way. (Both courtesy HSSNM: above, No. 3107B; below, No. 3107A.)

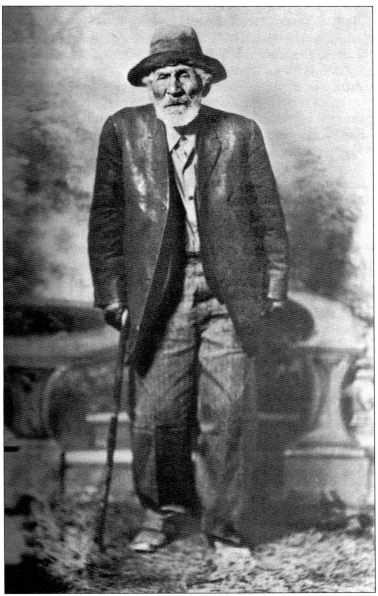

This man, Alejo Herrera, lived in Chihuahuita in the later years of his life and lived to be 117 years old, causing some to call him the "Methuselah of Chihuahuita." Herrera, who was born in 1819 and lived until 1936, led an interesting and adventurous life. He was born in Mexico and captured by Apaches at age 11; he did not escape them until age 30 in 1849, when a drunken brawl at the Apache camp finally gave him an opportunity. In his horseback getaway, Herrera also rescued a captive white girl. They both arrived safely in Santa Fe. Later, in the 1870s, Herrera was said to be a brave fighter in the infamous Lincoln County cattle war, and although it isn't said which side he fought on, he did hide outlaw Billy the Kid from the law twice, once rolled up in his bed roll. In his later years, Herrera took up residence in Chihuahuita and died under the care of friends, Augustin and Lola Garcia, when he passed away from extreme old age. (Courtesy HSSNM, No. 3051.)

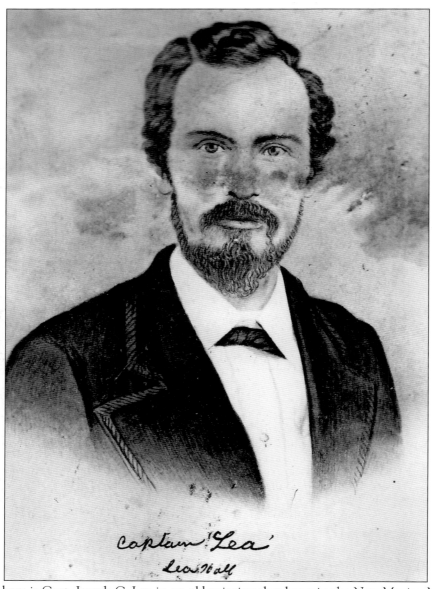

Shown here is Capt. Joseph C. Lea in an old painting that hung in the New Mexico Military Institute. Lea was a Confederate captain for most of the Civil War in Louisiana, but he was also a member of Quantrill's Confederate guerillas and also served in Shelby's cavalry for a time. Lea came to Roswell in the late 1870s, long after the war had ended, with his wife Sallie Wildy Lea. Lea acquired the boardinghouse and general store of Van C. Smith and took over the small settlement. Ironically, before Lea was a Roswell patriarch who forbade outlaw Billy the Kid from causing trouble in town, during the Civil War he was leader of a band of guerillas that consisted partially of the famous James brothers, which at times may have included the notorious outlaw Jesse James and his brother Frank. The most thorough amount of original research on Captain Lea's many adventures in Roswell and the Civil War are explored by Elvis E. Fleming in *Captain Joseph C. Lea: From Confederate Guerilla to New Mexico Patriarch*. (Courtesy Larkham Album 2, No. 1732.)

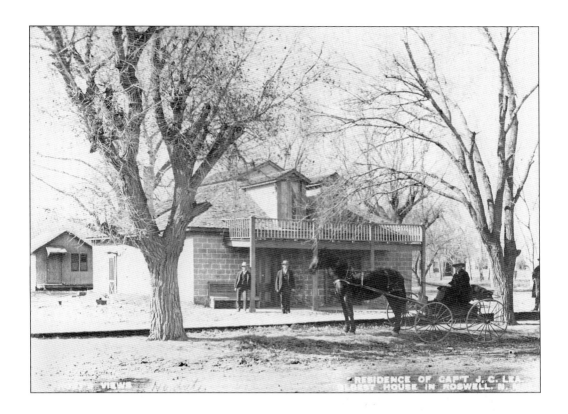

Pictured below is Roswell when it was still a small hamlet in the mid- to late 1880s. Above is the first building to ever be constructed in Roswell, built by James Patterson and later used as a boardinghouse by Capt. Joseph C. Lea. Van C. Smith added additional rooms and another half story to the structure when he acquired the property in 1870. This particular photograph of the boardinghouse, which also shows Captain Lea in the buggy, has raised some debate among historians. All records of the boardinghouse say it was built out of adobe, and it appears that way in early photographs of the structure. However, in this photograph, cinder blocks have clearly been added to the building. (Both courtesy HSSNM: above, No. 1977; below, No. 710E.)

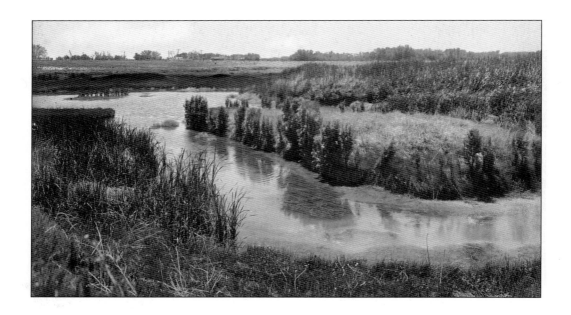

Many modern-day residents of Chaves County may find it hard to believe in today's barren landscape, but Chaves County used to be home to two sizeable rivers: North Spring River, which was 60 feet wide and 10 feet deep at its widest and deepest points, and South Spring River. Above and below are two separate views of South Spring River, which was an important facet of the southern Roswell area. Shown below is the head of South Spring River, and above, a marshy area of the river can be seen with both Brasher Road and the railroad visible in the background. (Both courtesy HSSNM: above, No. 568B; below, No. 2841S.)

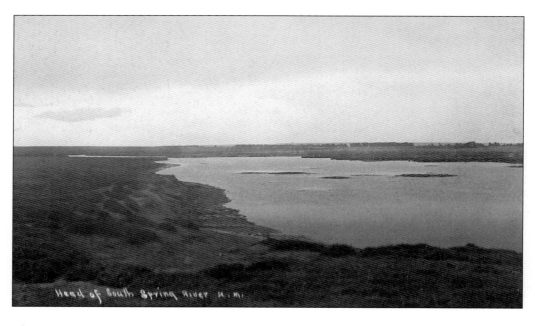

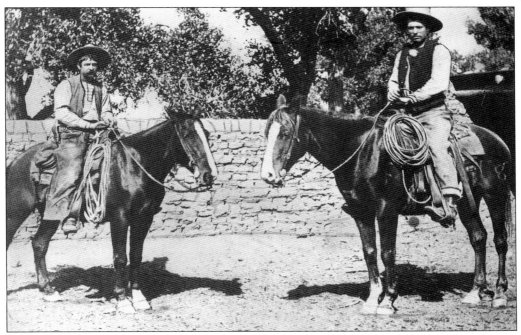

J. P. White (the man at right above; the man at left is unidentified) was born in Gonzalez, Texas, in 1856 and came to the Pecos Valley driving a herd of cattle in 1881 with his uncle George Littlefield. Littlefield purchased the Bosque Grande—John Chisum's first headquarters before he moved to South Spring—from Capt. Joseph C. Lea's sister, Ella Calfee Pearce, in the early 1880s. White became a prominent businessman in Roswell, and his home at 200 North Lea Street in Roswell now serves as the headquarters for the Historical Society for Southeast New Mexico. Below is a huge tree located on the old Bosque Grande property north of Roswell. The tree was measured at 23 feet in circumference by historian Maurice G. Fulton (right) and an unidentified man. (Both courtesy HSSNM: above, No. 539; below, No. 1440L.)

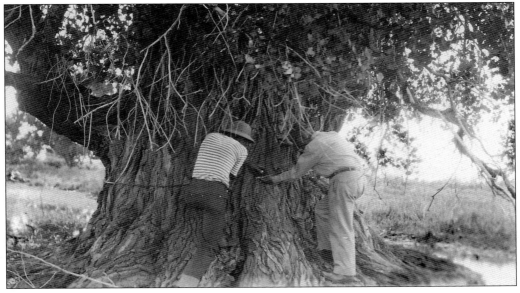

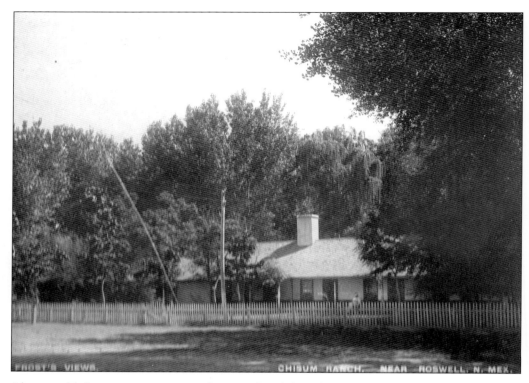

Above and below are two very rare photographs of the John Chisum ranch house at the South Spring River Ranch. The bottom photograph shows the house during a heavy snow in 1898, long after John Chisum had died and his nieces and nephews had left the property. In its day, the house was a cornerstone of the area, entertaining numerous high-profile people as well as the occasional outlaw. The ranch was later taken over by J. J. Hagerman, who, like Chisum, had a monumental impact on Southeast New Mexico. (Both courtesy HSSNM: above, No. 1818; below, No. 193B.)

Two

THE CREATION OF CHAVES COUNTY

By the late 1880s, Roswell was no longer a small hamlet and had become a full-fledged town that many of the residents felt was worthy to become its own county seat. So Capt. Joseph C. Lea, Charles B. Eddy, and Pat Garrett traveled to Santa Fe to see the Territorial Council and House with a petition requesting that new counties be carved out of Lincoln County, then the largest territory in New Mexico and the United States. Lea and Garrett were campaigning for Roswell to be the seat of its own county, as the distance to the county seat in Lincoln was quite far away, and Charles B. Eddy was there to request the town of Eddy (today Carlsbad) become its own county seat as well.

In this effort, James J. Dolan, a villain in the Lincoln County War and a council member of the Territorial House of Representatives, opposed the creation of these two new counties. In fact, when the council met in January 1889, the main discussion was whether to create these two new counties from massive Lincoln County. Still, despite objections, the bill creating the counties was passed on February 25, 1889.

When it came down to naming Roswell's county, the choice was obvious: Lea County, after Captain Lea. However, Captain Lea rejected this notion and requested the county be named for his good friend Col. Francisco J. Chaves (although an earlier county name suggested was Roswell County). Colonel Chaves was a member of a very distinguished Spanish family who had been leaders in New Mexico even as far back as the Spanish Colonial period. Chaves was also Speaker of the Territorial House in 1889, and Lea may have suggested the name to gain support. Lea later had a county named after him anyway when Lea County was created out of Chaves and Eddy Counties in the farthest southeastern corner of New Mexico in 1917.

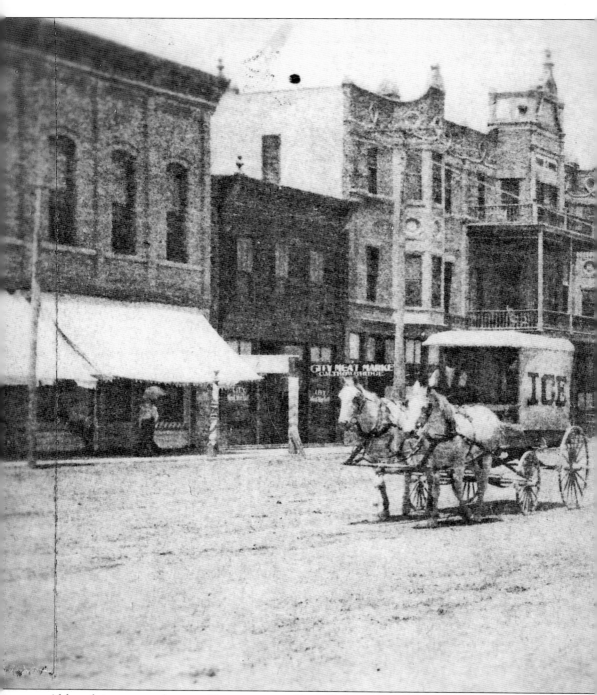

Although it was now the seat of its own county, Roswell, shown here around 1900, still had its Wild West troubles. "Roswell was a wild, wild town," remembers Lola Patterson, now one of Roswell's oldest residents, who heard stories about the town as a young girl from old-timers in the nearby town of Fort Sumner, New Mexico. One such wild story concerned the burning of a brothel some time in the late 1890s or early 1900s. Respectable businessman Joshua P. Church, unbeknownst

to his wife Amelia Bolton Church, owned a brothel on present-day Virginia Street. After Amelia found out about it, the brothel mysteriously burned down, and town gossip speculated that Mrs. Church, or possibly her handyman, was responsible. However, it should be noted no one was hurt, and the story could be apocryphal. (Courtesy HSSNM, No. 1564-22.)

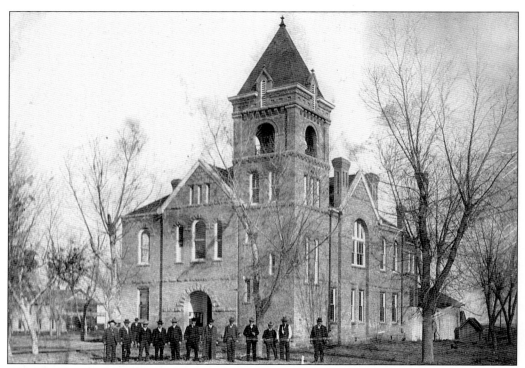

Above is the completed Chaves County Courthouse, built in 1890, and below are the county clerks of the interior office. In 1894, Chaves County had its first murder and, following that, its first hanging on what was to be a monumental day for all of New Mexico. All across the state, nine executions were to be carried out in what the Silver City, New Mexico, *Enterprise* called the "Hanging Bee" to "[beat] the record for the west." In the end, four men were hanged instead of nine, the first of whom, Antonio Gonzales, was in Chaves County. Two men would have been hanged there, but the first, Eugenio Aragon, killed himself with a shank he fashioned out of an old spoon in his courthouse cell. (Both courtesy HSSNM: above, No. 189B; below, No. 351.)

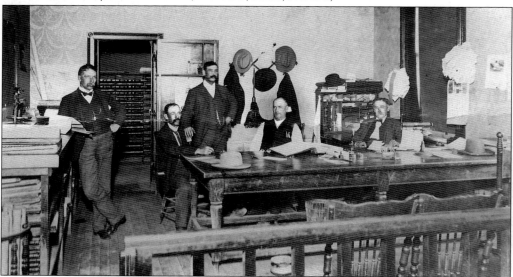

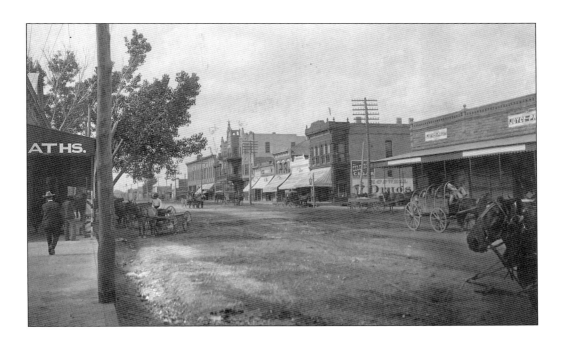

Shown above is Roswell's Main Street in 1900, and below is a smoky bar, the Green Front, which still stands today although abandoned as the Green Lantern on Main Street. Another copy of this photograph oddly labels the smoky building as being inside of the Joyce-Pruit Company. Listed in the 1896 photograph, in no particular order, are the following: Kemp Ragsdale, Dee Webb, and A. Pruit. (Both courtesy HSSNM: above, No. 710B; below, No. 1921.)

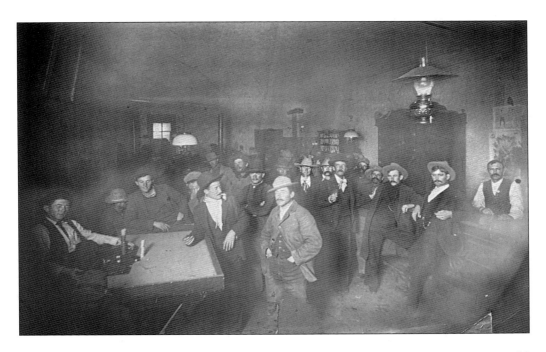

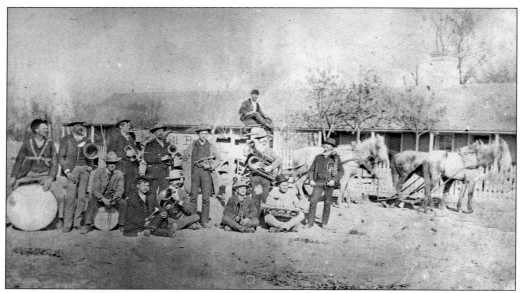

Roswell's first official band was formed in 1889. Posed at the old John Chisum ranch house are, from left to right, the following: Charles Grant, Lee L. Wells, Albert Frick, James Erwin, J. P. White, George Ovards, George Haffley, Lou Fullen, "Italian Frank," Bill Hunt, John F. Zimmerman, George Donaldson, and Sam Joyner. James Erwin and Lou Fullen were also the publishers of Roswell's first newspaper, the *Pecos Valley Register*. (Courtesy HSSNM, No. 268.)

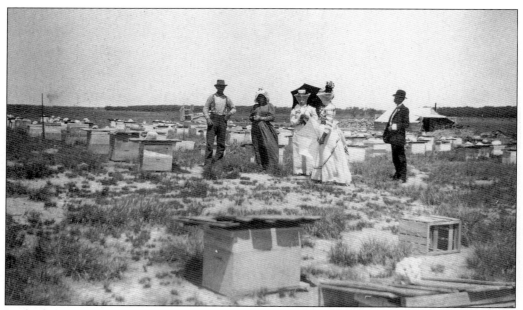

In the late 1880s, after the trees at South Springs on the Chisum ranch began to bloom, J. R. Slease brought in two hives of Italian bees to tend to the apple blooms. Eventually Slease acquired nearly 150 hives, which he made a profit off of by selling large amounts of honey. The Slease bee farm is pictured above on June 14, 1898. (Courtesy HSSNM, No. 018A.)

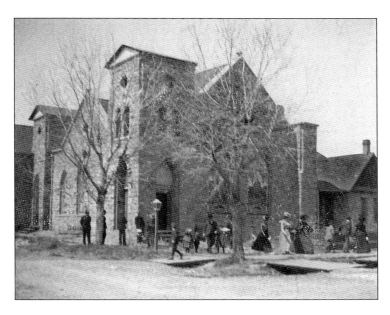

In this undated photograph, churchgoers leave the First United Methodist Church. It was the first church building to be erected in Roswell and the Pecos Valley. Before that, Helen Johnson held Sunday school services in a tent on her property in 1885. The board of trustees for the church consisted of Capt. Joseph C. Lea, Steve Mendehall, and William Prager. (Courtesy HSSNM, No. 162.)

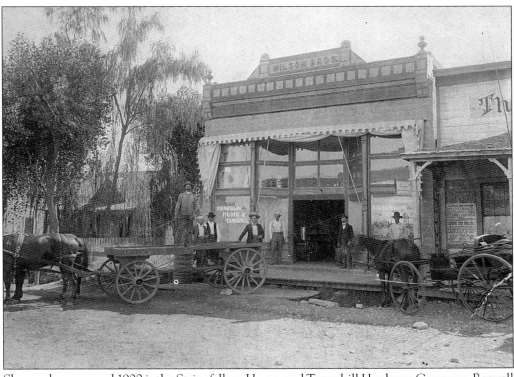

Shown above around 1900 is the Stringfellow, Hume, and Tannehill Hardware Company. Roswell got its first lumber company in the form of the Roswell Lumber Company on March 3, 1902. The name was later changed to the Pecos Valley Lumber Company. (Courtesy HSSNM, No. 827.)

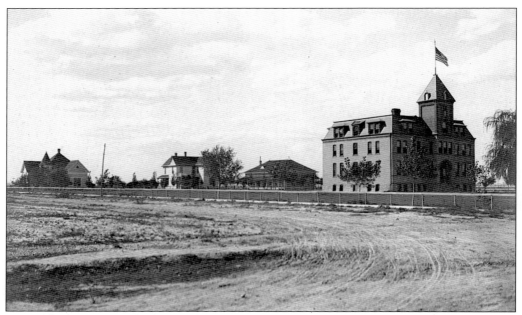

Above is a view of the prestigious New Mexico Military Institute, which began in another building under the leadership of Col. Robert C. Goss. The New Mexico Military Institute was originally called Goss Military Institute until the name was changed in order to receive state funding. The above structure, Lea Hall, was built in 1898. Below is a rare view of the old New Mexico Military Institute faculty cottages, where the superintendent also lived. (Both courtesy HSSNM: above, No. 7957; below, No. 165V.)

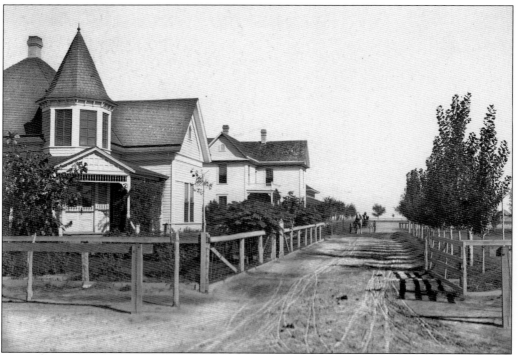

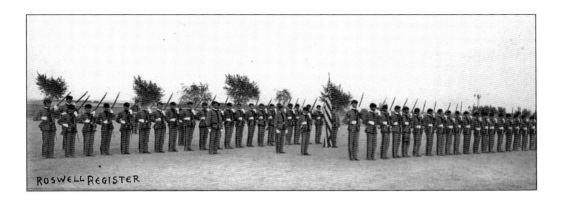

New Mexico Military Institute's cadets stand at attention in the 1910 photograph above. Below is the New Mexico Military Institute's 1904 baseball team. Standing as listed on the back of the photograph, from left to right, are the following: Harry Hamilton, Shelby Moore, Lucius Dills (Roswell newspaperman), Ross Malone, Drew Pruit, Longstreet Hull, Dick Ballard, Oliver Smith, Alex Ririe, W. C. Reid, R. M. Parsons, Cadet Kittridge (first name unknown), and Cadet Montoya (first name unknown). Sitting, from left to right, are the following: Jim Hamilton, Fred Hunt, E. W. Mitchell, Roy Mook, "Doc" Phillips, Hial Cobean, Ted Bedell, and Charlie Sher. (Both courtesy HSSNM: above, No. 165H; below, No. 165Q.)

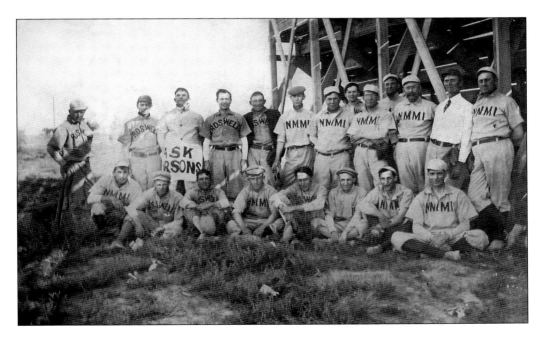

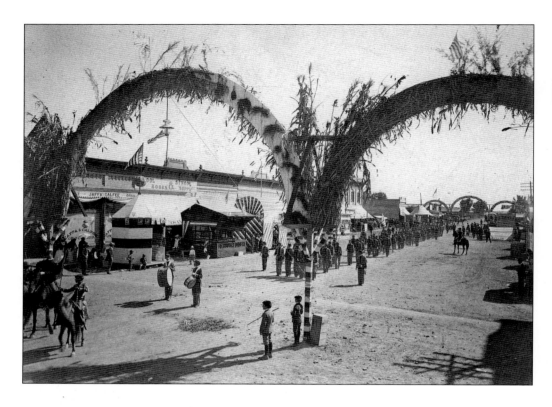

The above and below photographs show New Mexico Military Institute cadets marching in a parade down Roswell's Main Street for the Southeastern New Mexico and Pecos Valley Fair of 1900. The fair in Roswell began in 1892 and has continued annually in the fall ever since. Cadets from the New Mexico Military Institute, then Goss Military Institute, paraded down Main Street during the first 1892 parade as well. The above parade of the fair, held October 10–13, was known as the "Flower Fair" because many of the carriages and floats in the parade had an overt flower theme to them. (Both courtesy HSSNM: above, No. 165K; below, No. 383.)

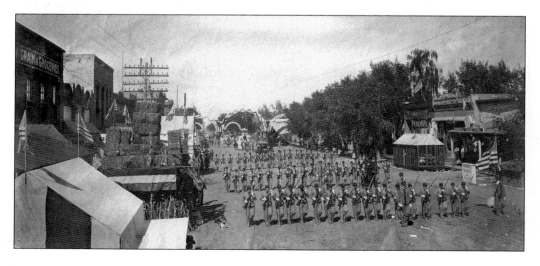

Shown here is the Joyce-Pruit Company, a very important Roswell business that helped many of the ranchers and farmers in the Pecos Valley. The store actually began in 1888 in Eddy under the name of Pennebacker-Joyce Company until Pennebacker's interests were bought out by A. Pruit. In 1893, a Roswell branch of the store was opened under the name of Joyce-Pruit Company. The store operated there until 1929. (Courtesy HSSNM, No. 1898A.)

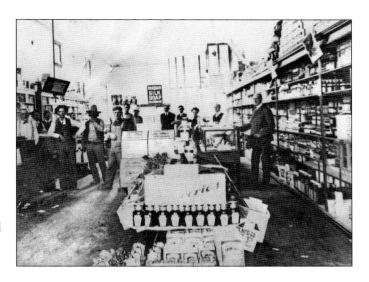

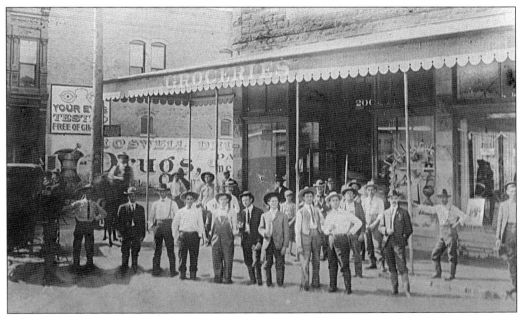

Many photographs, such as this one taken along Main Street, were taken during a flood because people broke out their cameras more often to capture how high the waters were. Notice the group of men's feet submerged underneath some floodwater in the photograph. Identified men in the front row are Jim Garner, Fred Miller, Charlie Joyce, A. Pruit, Charles Shepherd, and A. D. Boyer. (Courtesy HSSNM, No. 250A.)

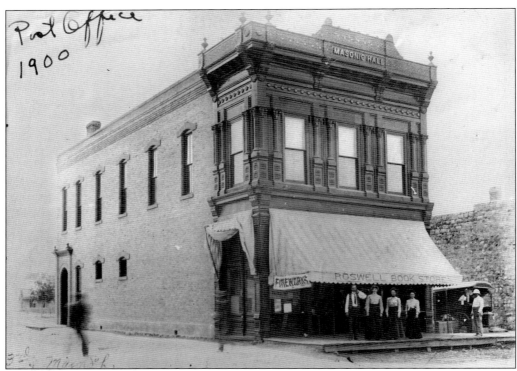

Roswell's Masonic Hall (shown above), which also housed the post office, was erected in the mid-1890s. This new structure was built after a fire destroyed the original lodge in 1893. The Roswell Masonic Lodge No. 18 began in 1889 and was the first fraternal organization in Roswell. In the photograph below, from left to right, are Ned Sparks, Frank Pearce, Ralph Parsons, unidentified, W. H. Cosgrove, M. Whiteman, John W. Poe, Charles Wilson, E. A. Cahoon, Joe Jaffa, Robert Kellahin, J. B. "Billy" Mathews, James W. Sutherland (Roswell's first doctor), M. W. Finley, and Leo Aarns, all of whom were prominent Roswell citizens and a few of whom were Lincoln County War veterans. (Both courtesy HSSNM: above, No. 1688B; below, No. 497.)

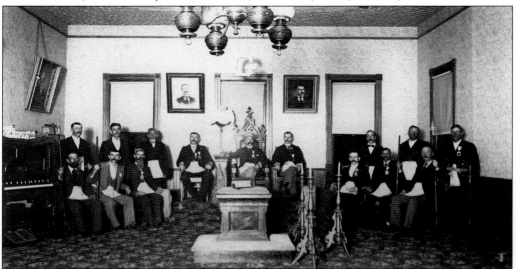

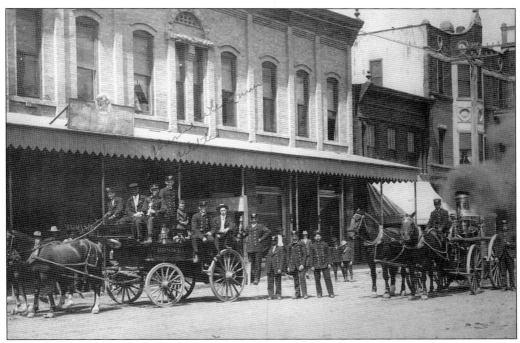

In 1893, Roswell suffered its first major fire, which consumed several businesses along Main Street and prompted the board of trustees to purchase a fire engine, 500 feet of hose, and a hook-and-ladder truck from the American Fire Engine Company in New York. Shown above is early fire equipment from the 1900s. Charles Whiteman was fire chief at the time, and Walter Gill of Roswell Seed was the assistant chief. (Courtesy HSSNM, No. 392.)

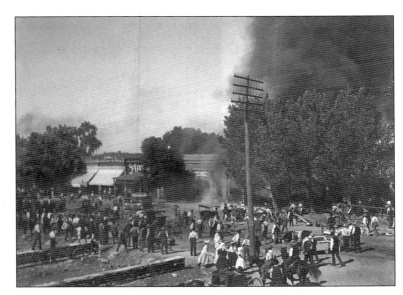

Pictured here is a fire that occurred on July 3, 1903, on East Main Street in Roswell, between Second and Third Streets. The fire began in George Freidenbloom's barbershop (obscured behind trees at right). To the left is Bonney and Sons Livery Stable, and next door is Stacy Paint Company, which today is the location of Bullock's Jewelers. (Courtesy HSSNM, No. 276A.)

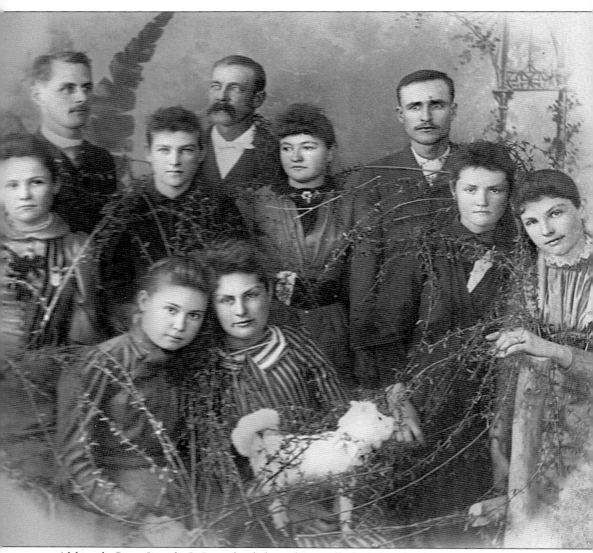

Although Capt. Joseph C. Lea, the father of Roswell, died shortly after being elected mayor in 1904, many of his family and relatives remained in Roswell. Several of them are featured in the above portrait. The back of the portrait does not discern who is who, but among the people in the picture are Gertrude Lea, Belle Buck, Helen Holloman, Mary Lea, Loretta Kearse, Eliza Fountain, Jennie Lea, B. Trother, E. Bull, and Joe D. Lea (who began the *Roswell Record*, which still operates today as the *Roswell Daily Record*). (Courtesy HSSNM, No. 569A.)

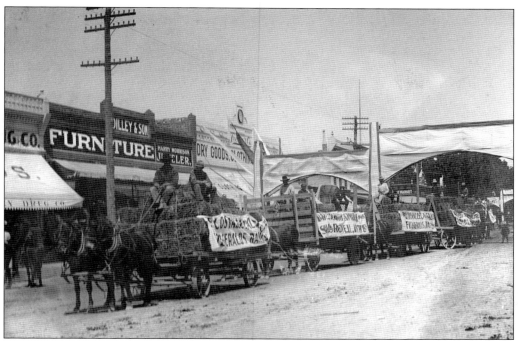

Above is a photograph taken during one of Roswell's numerous parades down Main Street. These hay wagons belonged to the Fitzgerald Ranch. The banners on the sides of the wagons read, "Pecos Valley Alfalfa, Fitzgerald Ranch." Agriculture was a very big part of Roswell life during the late 1800s and early 1900s, as proudly displayed in this photograph. In a different parade—the Old Timer's Day Parade—Charles Whiteman, who came to Roswell in 1885, holds up a sign next to a burro to illustrate how he arrived in Roswell 35 years ago. (Both courtesy HSSNM: above, No. 1172; below, No. 384.)

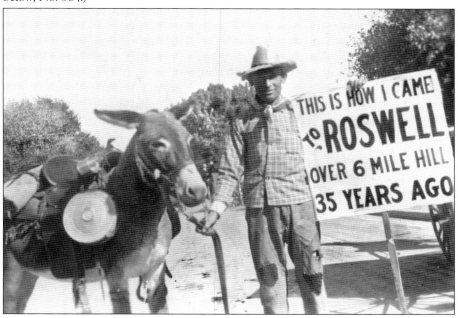

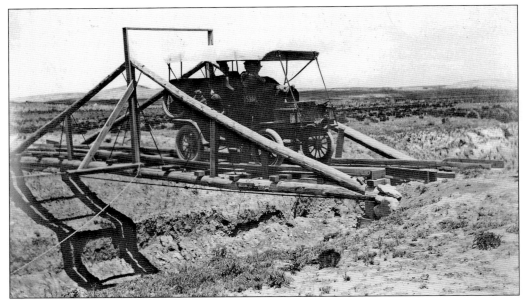

When it comes to mail routes, it turns out Roswell is rather historic. The first rural mail route in the New Mexico Territory was in Roswell, with Walter Gill of Roswell Seed as the first carrier. Even more historic is the fact that Roswell also had the very first automobile mail route in the United States when it began in 1906 from Roswell to Torrance. (Courtesy HSSNM, No. 219.)

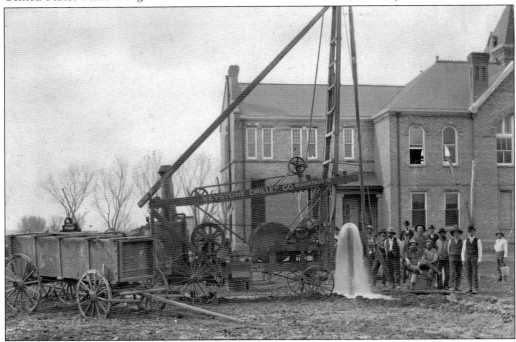

In 1890, artesian water was discovered in Roswell, and the madness began. When a drilling machine discovered the water in the backyard of Nathan Jaffa, many new settlers descended upon Roswell because of the abundance of readily available water. This photograph shows the drilling of an artesian well on the courthouse lawn in 1897. (Courtesy HSSNM, No. 189D.)

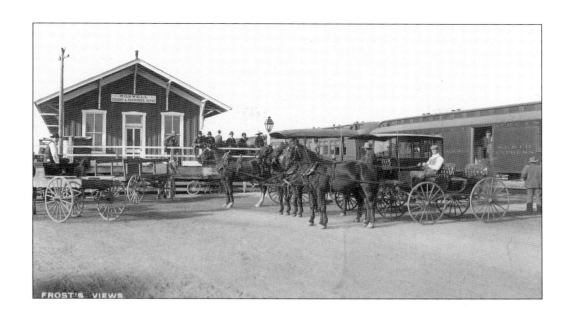

After the discovery of artesian water, the next big step in Roswell and Chaves County's development was the coming of the railroad. The railroad was thanks to J. J. Hagerman, who came to the area from Colorado with Charles B. Eddy. The railroad was completed with the first train arriving in Roswell—which claimed to be further from a railroad than any other town in the United States—on October 6, 1894. The Roswell Freight and Passenger Depot is shown above around 1894–1895 and again below in a picture that perhaps best captures both aspects of Chaves County's newfound prosperity: water and the railroad. (Both courtesy HSSNM: above, No. 2023; below, No. 1622A.)

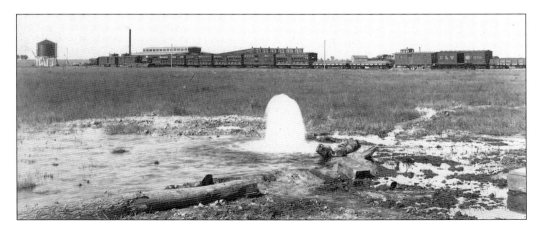

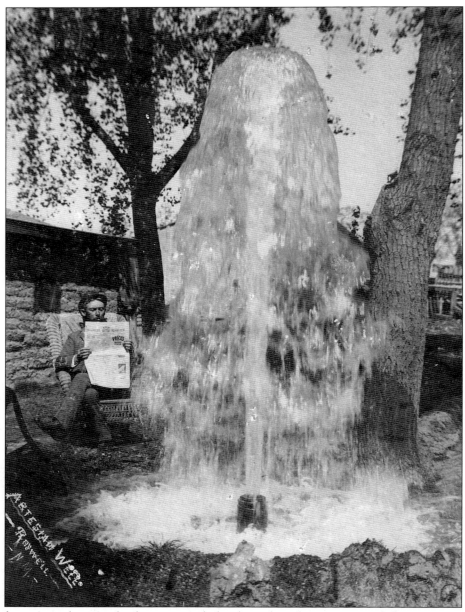

This humorous photograph of a man nonchalantly reading the newspaper while an artesian well gushes into the air perhaps best exemplifies the attitude of Roswell citizens towards the water: although excited by it, they took it for granted. An article from the *Santa Fe New Mexican* read: "Down at Roswell the people amuse themselves with a contest as to which can secure the deepest artesian well, as in other towns neighbors vie with one another in building fine homes. There are many of the spouters flowing from 200 to 1,000 gallons per minute each. It is an embarrassment of riches. Taking care of the deluge is becoming somewhat of a burden, and still more wells are going down. The stream of a well is easily shut off, but is rarely checked, because it is a delight to see the water." The wells in Roswell flowed without much regulation or restriction and began to dry up in the early half of the new century. (Courtesy HSSNM, No. 547.)

Three

DEXTER, HAGERMAN, AND LAKE ARTHUR

The discovery of artesian water and the incorporation of Chaves County in the 1890s could not have coincided at a better time, as the county saw the birth of several new communities due to the close county seat of Roswell and a readily available water source in the artesian wells.

Although several settlements sprang up, only three of those became full-fledged towns and remain a mainstay of the area: Dexter, Hagerman, and Lake Arthur. All three are relatively small, with populations of around 1,000 people each today.

Another large part of the towns' foundings was the coming of the railroad, which started in Pecos, Texas, then went to Carlsbad (then called Eddy), New Mexico; from there to Roswell; and from Roswell to Amarillo, Texas. Looking at a Chaves County map, one will notice Dexter, Hagerman, and Lake Arthur, in that order, are all in a line south of Roswell, because that is where the railroad went.

The first of the new towns was Hagerman. The town came into being indirectly thanks to the development of the large canals in Roswell by Charles B. Eddy and former sheriff Pat Garrett in the late 1880s. Eddy had gone to Colorado to get further investing for the project from Robert Weems Tansill, the famous cigar maker. Instead Tansill introduced Eddy to J. J. (John James) Hagerman, a wealthy investor who had prospered from gold, silver, and coal mining in Colorado, among other things, as well as from considerable experience in the railroad business. When he came to the Pecos Valley, he saw a land he could shape to his liking and invested in the Pecos Irrigation and Improvement Company, thus giving Garrett the boot. The birth of the town of Hagerman came a few years after, and J. J. Hagerman even bought the old John Chisum ranch near Roswell to build a home (called a "mansion" by Roswellites). Dexter emerged following the completion of the railroad from Eddy to Roswell in 1894, although it already had a few settlers, notably the Hobbies and Cazier families. Lake Arthur sprang up later, in the early 1900s.

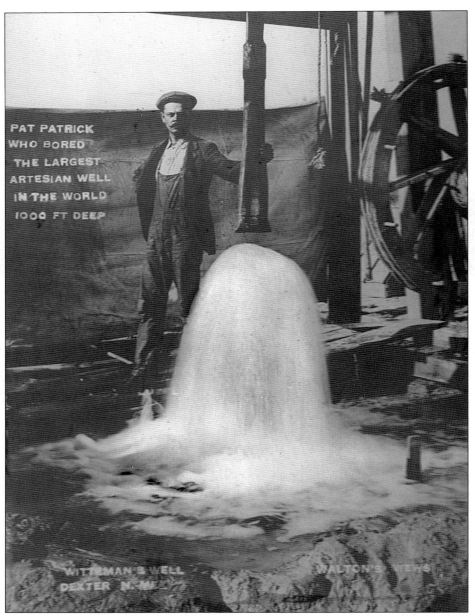

In January 1903, members of the Dexter Townsite Company, consisting of Albert E. Macey of Illinois, Theodore Burr of Denmark, and Milton H. Elford of Canada, filed articles of incorporation with the territory to establish the town of Dexter, named after Macey's hometown of Dexter, Illinois. More than a decade earlier, homesteads had already begun on Dexter land by the Cazier family. However, once artesian water was discovered in the area and the railroad was put into place, the homesteaders decided to stake out a whole new town in the area. Dexter would not officially be incorporated as a town until April 1910, with Jerry Cazier as the first mayor. Pictured above is an artesian well drilled by Pat Patrick in Dexter. Many photographs of the wells in Chaves County were taken, and almost all of them claim to be the "largest artesian well in the world." (Courtesy HSSNM, No. 402.)

Before this post office (above) was put into place, Dexter residents had to travel all the way to Eddy to get their mail. For a time in the late 1890s, there was also a post office at nearby Lake Van, often incorporated as part of Dexter but sometimes thought of as its own settlement. The Lake Van Post Office closed when Dexter residents began to get their mail from the Hagerman Post Office in 1898. Finally, in 1902, Dexter had its own post office, shown in the old shack above. The post office relocated several times and eventually moved into the Farm and Loan building below, which was built in 1906 and operated by Jerry Cazier and Garnet Stone. (Both courtesy Larkham Album 8: above, No. 2981-11; below, No. 2981-8.)

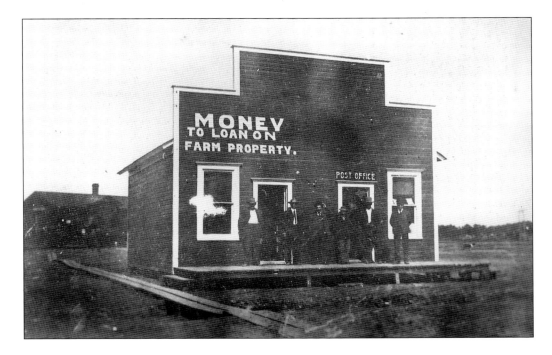

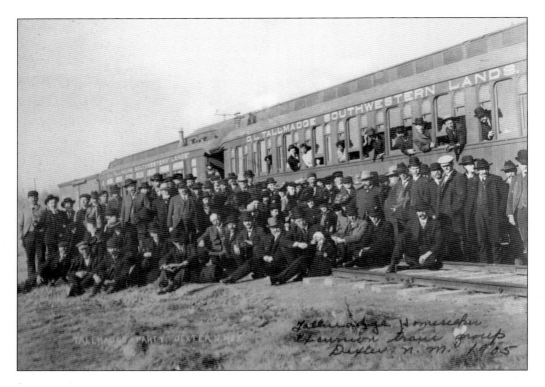

The above and below photographs were taken on January 7, 1905, during a home seekers' excursion to Dexter. These excursions were important to the Dexter–Hagerman–Lake Arthur area in bringing new settlers to the region. This was accomplished via two organizations, C. L. Tallmadge Southwestern Lands and Pecos Valley Immigration Company, wherein prospective settlers were brought to the area via train to view potential farmland to settle upon. In Roswell, famous politician "Sockless" Jerry Simpson was a land agent. (Both courtesy HSSNM: above, No. 570D; below, No. 570A.)

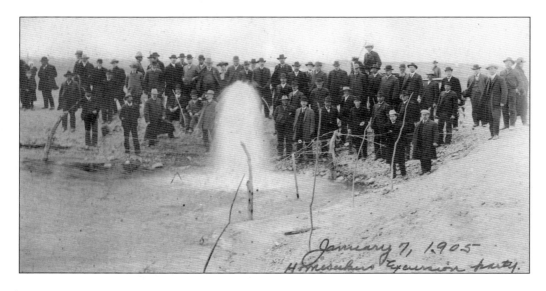

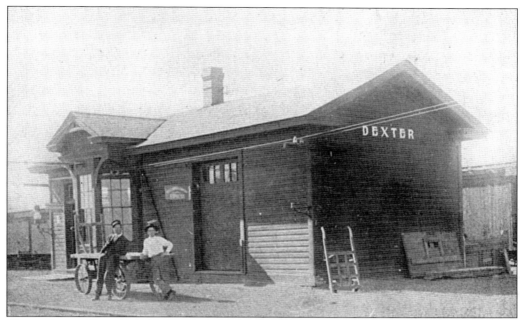

Shown above is Dexter's railroad depot in 1904. The depot was operated by Orlo Robbins, who lived in the same building, along with his mother and sister. One of the men in the above photograph is another agent, Walton Halliburton. (Courtesy HSSNM, No. 708.)

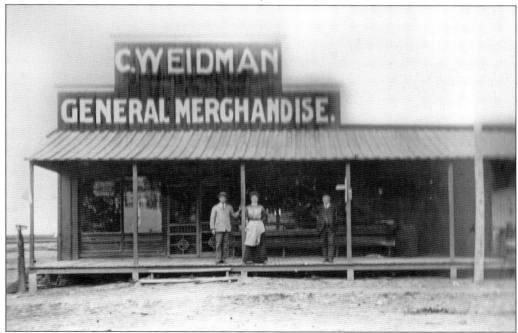

C. Weidman General Merchandise was Dexter's first general mercantile. It was built in 1902 by Charlie White, who also had a store in Hagerman. Pictured on the front porch here are Charles Weidman (far right), who purchased the store in 1906, store clerk Effie Bradley (middle), and Weidman's son Edwin (far left). (Courtesy Larkham Album 8, No. 2981-6.)

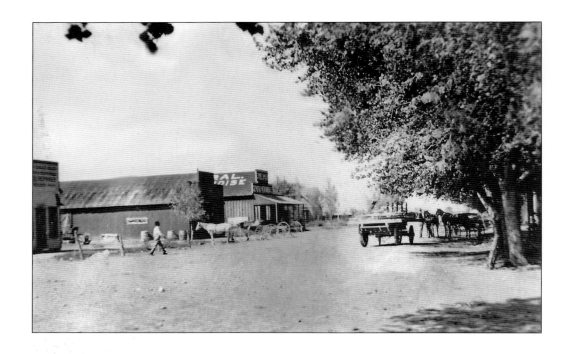

Shown above is Lincoln Avenue in Dexter looking to the north. Among the businesses pictured here are, from left to right, Elford Insurance, Tallman and Hair Machine Shop, and C. Weidman General Merchandise. Across the street, obscured by the large tree, are the Hiram Girard house, Dexter Beauty Shoppe, and the Elrick Saloon. The c. 1908 image below shows a bridge over the Northern Canal (which also flowed east of Roswell) on Dexter's western edge. (Both courtesy Larkham Album 8: above, No. 2981-3; below, No. 611.)

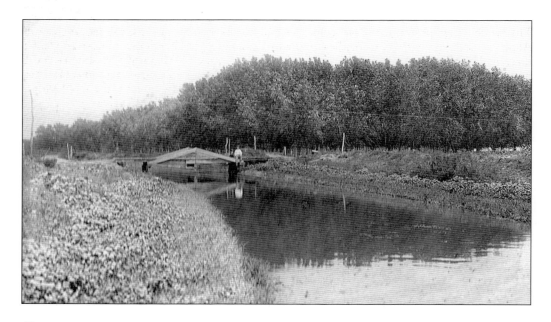

The two photographs on this page display several homes in rural west Dexter looking north. Above is the home of the J. L. Bradley family in 1906. Below is a panorama of western Dexter taken in 1908. The far left home belonged to Fred Mielenz, and to the north of that home is the house belonging to the Warren family. In the center is the George Pollock home, and at far right, to the north behind the small bungalow built by Jessie Blough and her sister, is the D. McVicker home. (Both courtesy Larkham Album 8: above, No. 2974; below, No. 2981-1.)

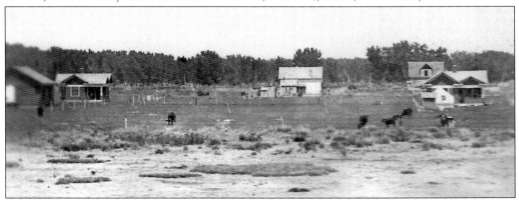

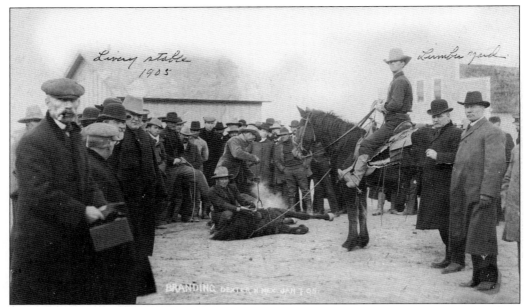

This picture was another one taken in 1905 for the home seekers' excursion in Dexter. Sam Butler brands a bronc in front of the Menn Livery Stable while Art Cazier holds it down. The man on the horse (right) is Earl Weldon, and the man in a light-colored hat and dark overcoat (fourth from left) is Mr. Gallup, the Tallmadge Land agent from Oklahoma. (Courtesy HSSNM, No. 570B.)

This Dexter Hotel was built in either in 1904 or 1905 by Charlie Card. Card sold the hotel and left Dexter in 1906. (Courtesy Larkham Album 8, No. 2987-3.)

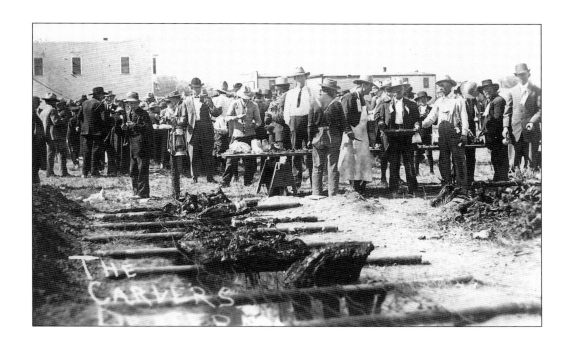

The above and below photographs show barbecues in Dexter on the Fourth of July in 1907 and 1906 respectively. In the background of the image above is the Clark Hotel (far right), which burned down years later. The social life in early Dexter consisted of several clubs, the first of which was the Ladies Club, organized in 1907. In 1908, a commercial club was formed by Dexter merchants who promoted the town and its 22 businesses. (Both courtesy Larkham Album 8: above, No. 4004-3; below, No. 789.)

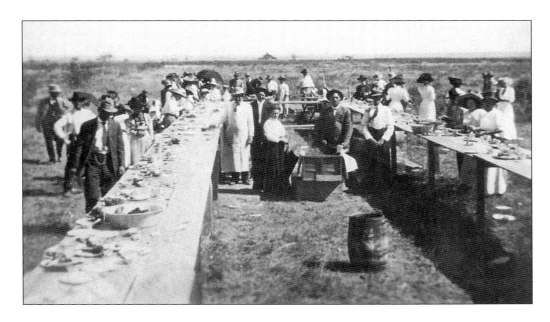

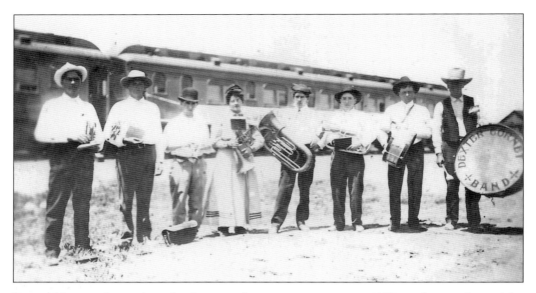

Pictured here in front of another home seekers' excursion train in 1907 are the members of the Dexter Cornet Band, directed by Captain Fletcher of the New Mexico Military Institute in Roswell. From left to right are Jeff Caffall, Stanley Hair, Leo Halliburton, Leslye Hair, Walton Halliburton, Davy Jones, and George Douglas. Below in another 1907 Dexter Cornet Band photograph (taken in Elford Park, where Dexter Town Hall now stands), from left to right, are (standing) Davy Jones, Walton Halliburton, Orlo Robbins, Joe Wolf, Alma Bradley, Leslie Hair, Boyd Atherton, Neil Whitman, and Art Ashton; (kneeling) Jeff Caffall, Stanley Hair, and Frank Sunderman; (seated) Tony Sunderland, unidentified, and Jerry Cazier. (Both courtesy Larkham Album 8: above, No. 2999-2; below, No. 863.)

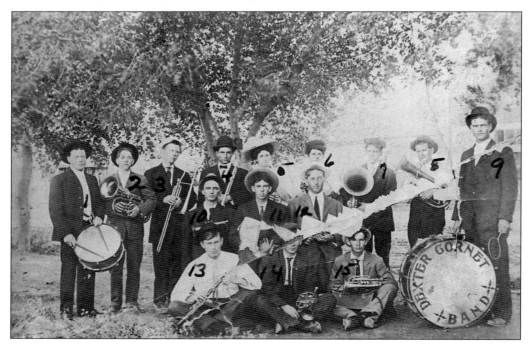

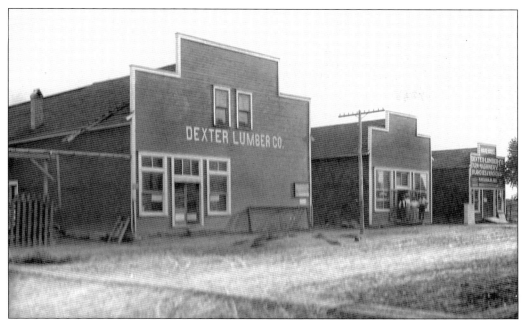

Shown above is the Dexter Lumber Company. Notice how the two following buildings to the right are built nearly identically, only smaller. The other two buildings are also part of the Dexter Lumber Company, and the last building's lettering reads, "Dexter Lumber Co. Farm-Machinery-Buggies & Wagons." (Courtesy HSSNM, No. 1840G.)

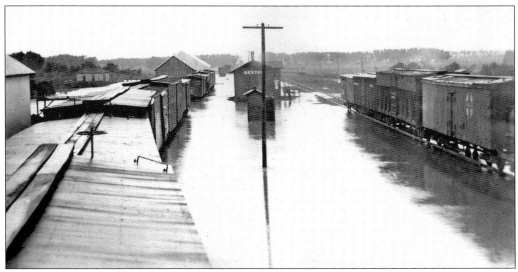

This picture shows the Dexter train yard in the aftermath of a large flood on July 24, 1911, when a huge cloudburst west of town flooded Zuber Draw. (Courtesy Larkham Album 8, No. 2981-7.)

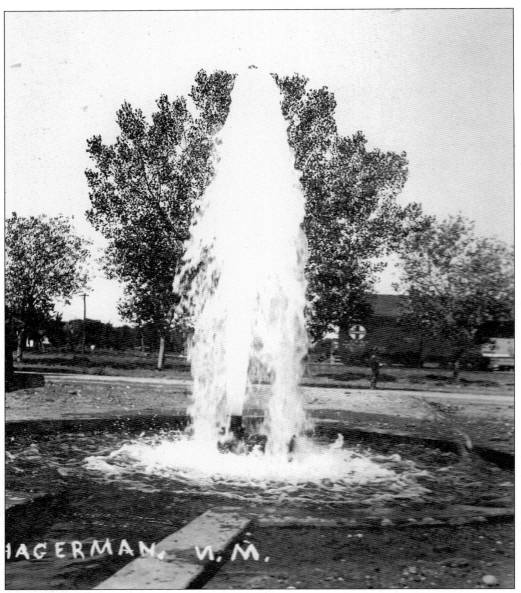

Shown in the picture above are two of the main facets of Hagerman's founding: the artesian well in the foreground and the railroad depot in the background. "Favorably located near the center of one of the finest and most fertile valleys in the arid region is the beautiful little city of Hagerman, which, though less than a year old, promises to be the most prominent town in the Pecos Valley," boasts the old town newspaper, the *Hagerman Irrigator*, in an August 3, 1895, news item. It continues to say of artesian water, "An artesian well has recently been sunk on the school grounds and a good flow of water was obtained at a depth of 295 feet, though the well is being sunk deeper, it being the purpose to get the strongest flow possible. Good drinking water can be found anywhere in town at a depth not exceeding twenty-five feet." J. J. Hagerman believed in his new town so much so he even placed advertisements for it in eastern newspapers to attract new settlers. (Courtesy HSSNM, No. 598.)

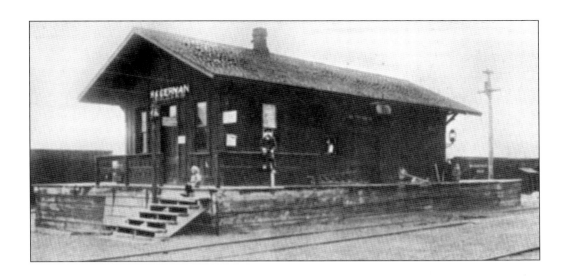

Shown above is the old wooden Hagerman railroad depot, and below is the new Santa Fe railroad depot built in Hagerman in 1910 and finished in 1911. The Santa Fe Railway took control of the depots of the Pecos Valley and Northeastern Railway (owned by J. J. Hagerman) in 1901. The new structure was built in 1910, thanks to the tremendous growth Hagerman was experiencing at the time. The Alfalfa Mill and the Alfalfa Growers Association, in addition to several other businesses, were operating in the town with much success. (Both courtesy HSSNM: above, No. 571; below, No. 2599.)

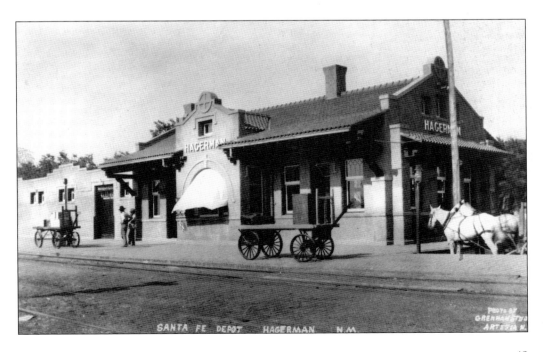

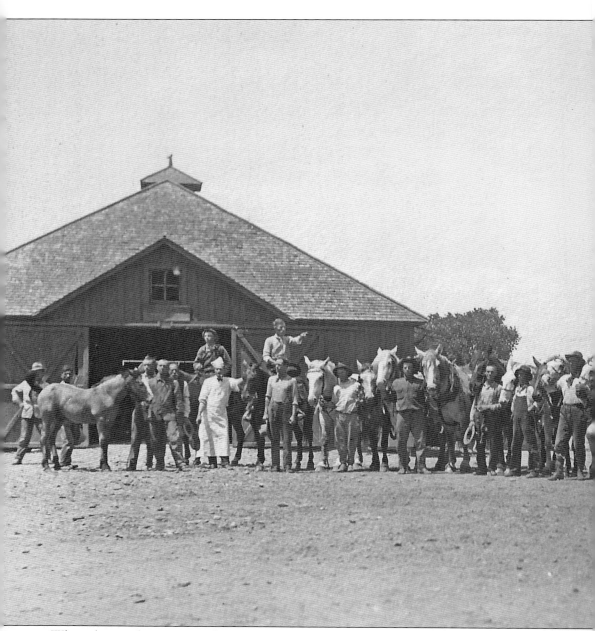

When platting the town site of 67 acres in 1894, J. J. Hagerman decided to name the streets with British names based on his British-Canadian heritage. Aberdeen Street was the north boundary and Oxford Street was the south; in addition there was Argyle, Winchester, Cambridge, Inverness, Perth, Manchester, and York Streets. Aberdeen and York Streets were made wider in anticipation

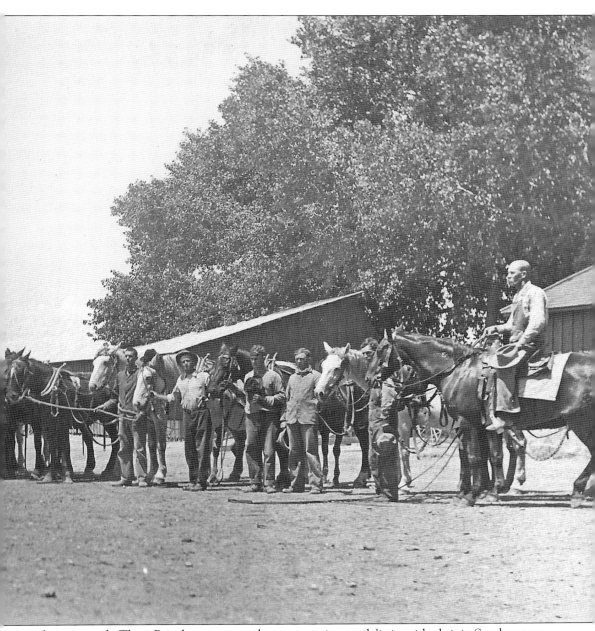

of town growth. These British names gave the town a unique and distinguished air in Southeastern New Mexico. Shown above is the whole crew of Hagerman Place in 1905, the year in which the town was fully and officially incorporated. (Courtesy HSSNM, No. 2026.)

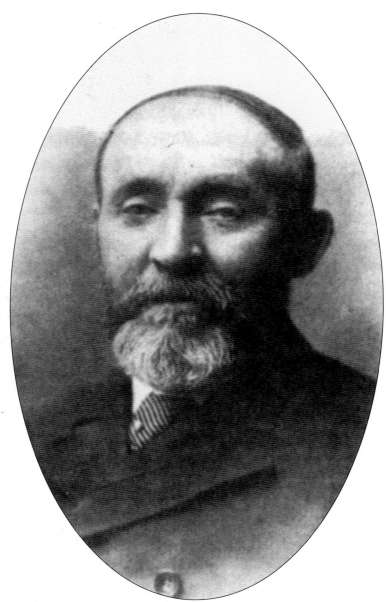

J. J. Hagerman led a fascinating life that took him to many interesting places. Hagerman was born on a farm near Port Hope, Ontario, in Canada on March 23, 1839. Hagerman had a rough upbringing with an alcoholic father, who often made his son work 12 hour days in whatever business he was running at the time. Eventually Hagerman split from his father to enroll in the University of Michigan in 1857. There Hagerman worked for Captain Ward, the owner of a shipping business on the Great Lakes, and in a short time, Hagerman graduated from Ward's employee to his trusted colleague. In 1865, Captain Ward made Hagerman the manager of his new railroad iron manufacturing company. It was also around this time that Hagerman married his wife, Anna Osborne of Detroit. Eventually Hagerman made a fortune from iron ore in Michigan and, later, gold in Colorado, where he met Charles B. Eddy, who enticed him to relocate to the Pecos Valley. (Courtesy HSSNM.)

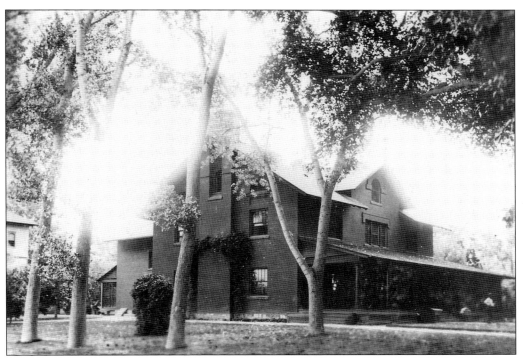

Shown above around 1914 is the three-story Hagerman mansion, which was built in 1901 on John Chisum's old property on South Springs Ranch, 6 miles south of Roswell. Although J. J. Hagerman had interests in Southeast New Mexico for the decade prior, he and wife Anna only moved to South Springs from Colorado the previous year, in 1900. Shown below is the private train car J. J. Hagerman kept at South Springs Ranch, which caused much discussion among Roswellites. J. J. Hagerman passed away in Milan, Italy, on September 15, 1909. (Both courtesy HSSNM: above, No. 992; below, No. 1884.)

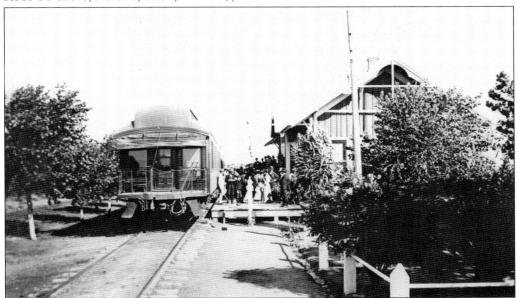

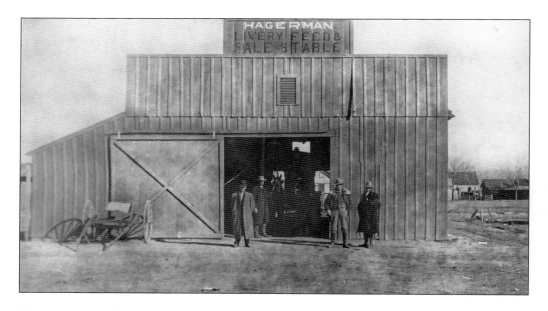

Shown above and below are two views of the Hagerman Livery, Feed, and Sale Stable. Citizens of Hagerman lobbied to create a Hagerman County in 1906. With J. J. Hagerman's son, Herbert J. Hagerman, now in office as the governor of New Mexico, they believed they would have enough support to carve out a new county from southern Chaves and northern Eddy Counties. It was not meant to be however, and no such county ever came into existence. (Both courtesy HSSNM: above, No. 1779; below, No. 598.)

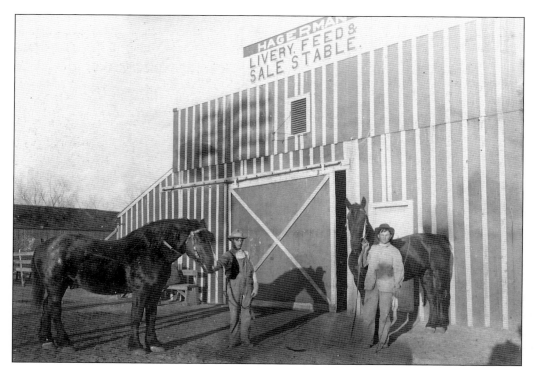

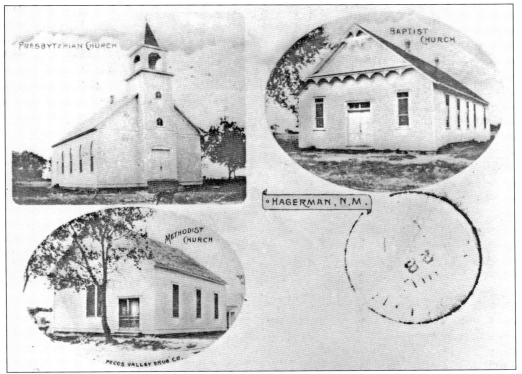

Like Roswell, Hagerman had several churches of different denominations. In the composite above (shown clockwise from left) are the Presbyterian church, Baptist church, and Methodist church in Hagerman. (Courtesy HSSNM, No. 1787.)

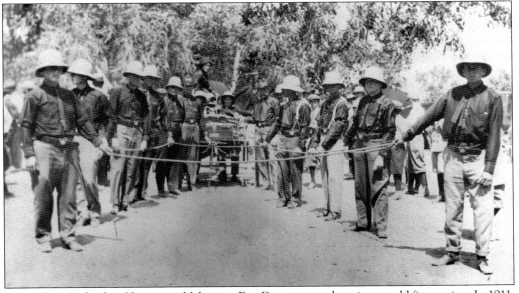

Shown here is the first Hagerman Volunteer Fire Department dragging an old fire engine. In 1911, the town purchased a 580-pound, 36-inch fire bell, and the first fire engine in Hagerman was a hand-drawn cart with two 35-gallon chemical tanks. (Courtesy HSSNM, No. 2522.)

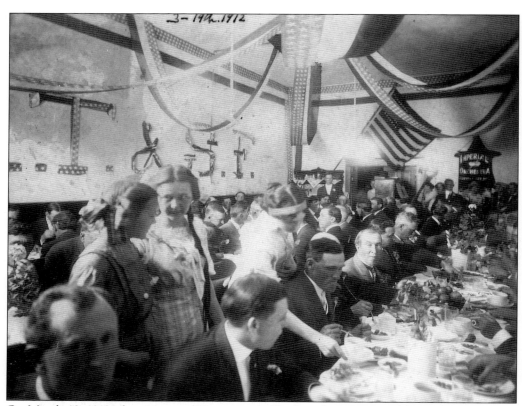

On March 19, 1912, the citizens of Hagerman held a huge banquet to celebrate the opening of their new railroad depot. Back in those days, the local railroad depot was a sort of gathering place and the site of much activity for many small-town residents. Many people would frequent the depots in the evenings to see the trains. (Courtesy HSSNM, No. 867.)

The First National Bank in Hagerman was built in 1906. E. A. Cahoon, who had established the first bank in Roswell, was on the board of directors along with J. J. Hagerman's son, Herbert J. Hagerman, who was also governor of New Mexico for a time. John W. Warren was president of the bank. (Courtesy Larkham Album 8, No. 2869.)

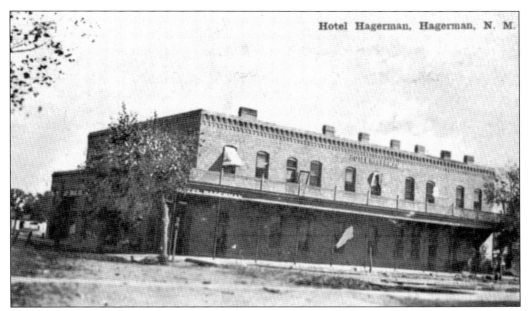

With a cost of $19,000, the Hagerman Hotel, one of the grandest hotels in all of the Pecos Valley, opened its doors in October 1906. Hagerman Hotel was located on the corner of Argyle and Cambridge Streets. The upstairs operated as the hotel, while the bottom was home to the Joyce-Pruit Company store as well as the Hagerman Drug Store and a dining room. The brick building was elegantly furnished with bird's-eye maple and mahogany furniture. The hotel mysteriously burnt to the ground on February 14, 1915. (Both courtesy HSSNM: above, No. 620; below, No. 1699.)

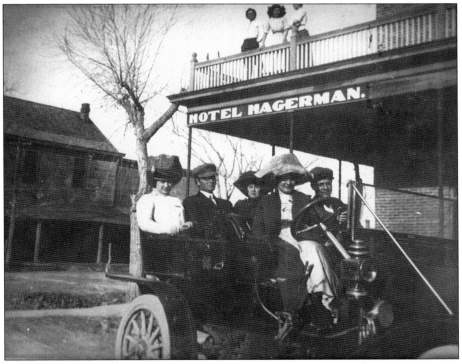

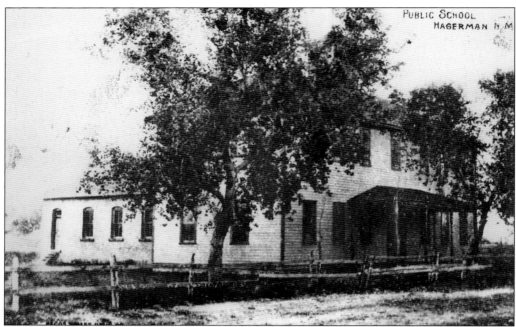

Shown above is the Hagerman schoolhouse. The first Hagerman schoolhouse was erected in 1895 at the corner of Inverness and Winchester Streets. About 80 students, ages 5 to 19, attended the school. In 1910, a new schoolhouse was erected. It is unknown whether the old or the new schoolhouse is pictured above. The odd-looking vehicle below is actually a school bus that was used to ferry children around the Dexter area. (Both courtesy HSSNM: above, No. 2535; below, No. 2566.)

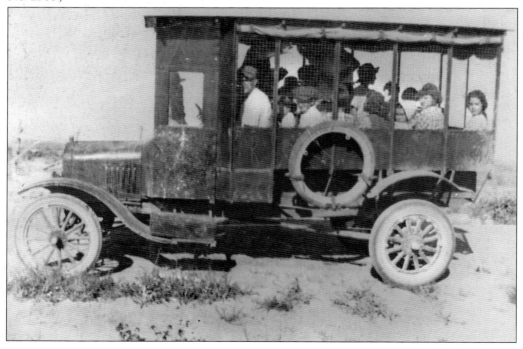

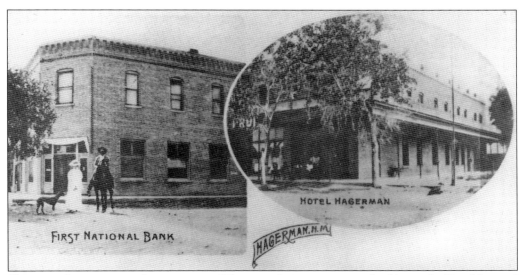

Shown in the composite above are two of Hagerman's most important buildings, the First National Bank and the Hagerman Hotel. The biggest business in Hagerman, by far, was alfalfa harvesting, and while Roswell is known as the Dairy Capital of the Southwest, Hagerman holds the distinction of being the Hay Capital of the World. (Courtesy HSSNM, No. 2633.)

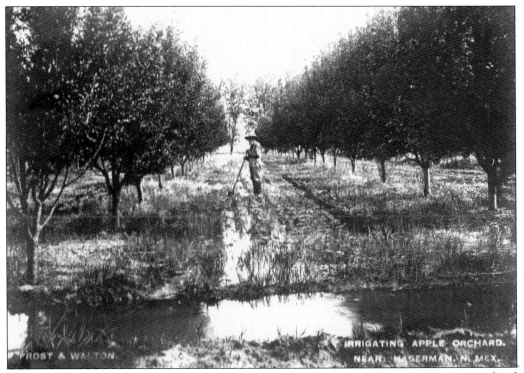

Shown here is an apple orchard and irrigation ditch in Hagerman. This was a separate orchard located in Hagerman and should not be confused with the Hagerman Apple Orchard on the old John Chisum ranch in Roswell, north of Hagerman. (Courtesy HSSNM, No. 3057.)

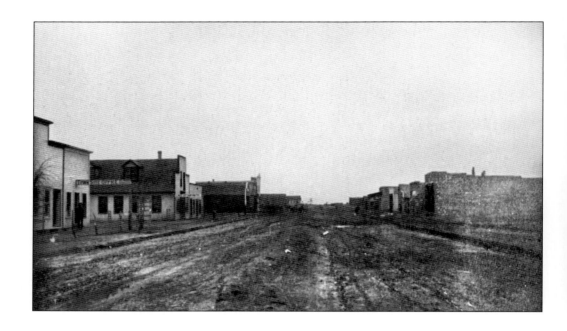

Shown above and below are several businesses from the early 1900s in Lake Arthur, another small town in Chaves County that was surveyed and platted in August 1904 and incorporated as a village in 1906. There is no lake at the current site of Lake Arthur, and local lore reflects there was never a lake there in the first place. The town, lake or not, was named after a local shepherd, Arthur V. Russell, who homesteaded in the area of the current town site. (Both courtesy HSSNM: above, No. 158B; below, No. 158H.)

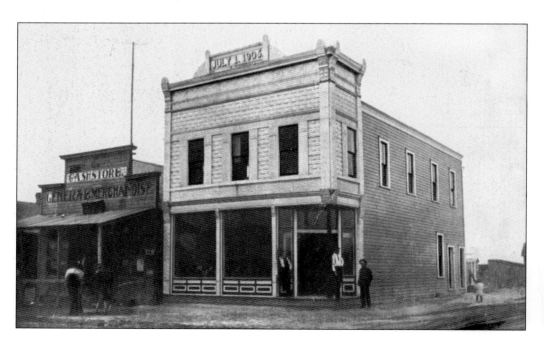

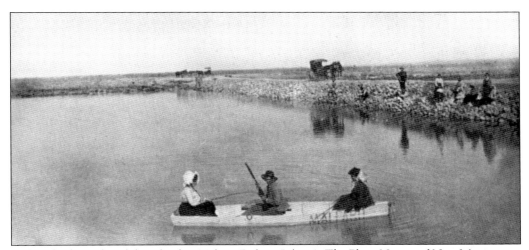

Is this the legendary lake of Lake Arthur? Robert Julyan's *The Place Names of New Mexico* says that there was a lake south of Lake Arthur, then known as Tar Lake. Others say that a small basin occasionally filled with rainwater to make a sizeable pond that locals called Lake Arthur. Perhaps the better question though is why is this man carrying a shotgun to go fishing? (Courtesy HSSNM, No. 158G.)

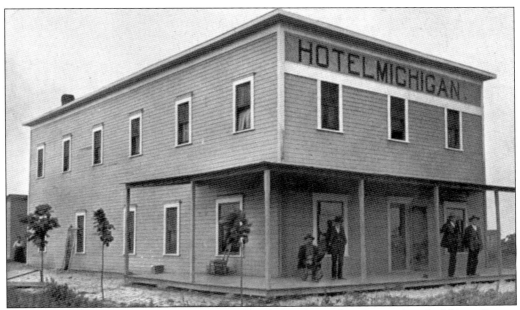

An old article in the *Roswell Morning Dispatch*, titled "Lake Arthur Situated in the Nerve-Center of the Prospective Oil Fields," says the town is situated in the heart of the "artesian belt" and has one of the most agreeable climates in the world where "snow is unknown." Shown above is the Hotel Michigan in Lake Arthur in 1905. (Courtesy HSSNM, No. 158C.)

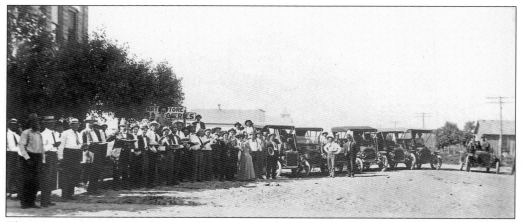

This town gathering took place in 1915 during the Lake Arthur Watermelon Feast. Years before, in 1907, temperance leader Carry Nation visited Lake Arthur in 1907. During this time, she and several other women rolled whiskey barrels from the local saloon out onto the street and slashed them apart with hatchets. (Courtesy HSSNM, No. 835B.)

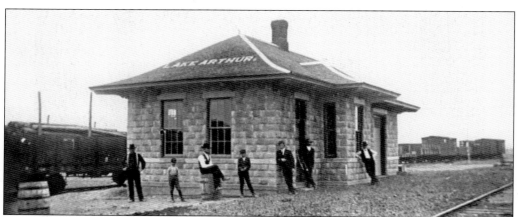

Shown here is the Lake Arthur railroad depot, built by Lake Arthur citizens in 1906. The first post office opened in Lake Arthur in 1905, with Joseph Boyd, also owner of the first town grocery store, as postmaster. (Courtesy HSSNM, No. 1739.)

Lake Arthur is notable for being home to the first female mayor in New Mexico, Ella Becker. Becker was elected chair of village trustees and ex-officio mayor in 1925. Becker had to leave before her term expired and was succeeded by another woman, W. V. Evans, the second female mayor in New Mexico. In the photograph above is the M. O. Becker home in 1908 and, from left to right, are the following: Gene Becker, Will Becker, Jake Becker, Annie L. Snorf, Dorothy Becker, Amy Becker, Allena Becker, Ella Becker, and M. O. Becker. Below are members of the Euraka Rebekah Lodge No. 5 in Lake Arthur. (Both courtesy HSSNM: above, No. 214; below, No. 094.)

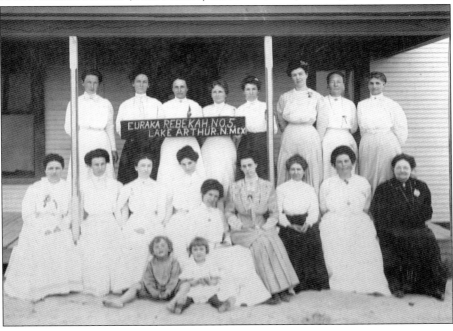

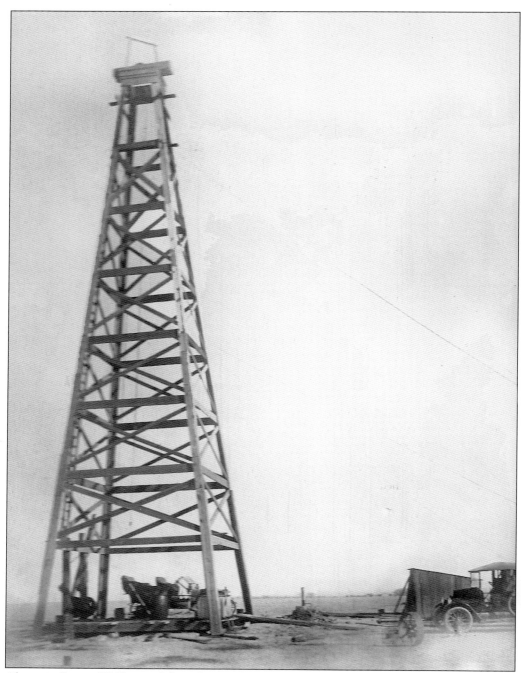

Above is Groves Well, an oil derrick owned by the Lima Vista Oil Company in Lake Arthur, photographed on January 31, 1918. Also pictured are a small shed and a six-cylinder Ford used in bailing the oil. The Linda Vista Oil Company acquired the well from the Pecos Valley Petroleum Company in January 1918. The first board of directors for the Linda Vista Oil Company consisted of Milton McWhorter, president; J. S. Dillenbrick, vice president; G. W. Butler, secretary; Charles Curry, treasurer; and Ella M. Becker and Dr. W. A. Lang, directors. (Courtesy HSSNM, No. 246.)

Four

Rural Roswell

Roswell, and the rest of Southeastern New Mexico, has always had strong ties to cattle. Today Roswell is known as the Dairy Capital of the Southwest. However, when the cattle boom began in southeast New Mexico, the cattle were not used as part of the dairy industry (that came later), but as part of the beef industry.

It all started with John Chisum coming into the area in the late 1860s. Even after Chisum died in 1884, cattle remained a major facet of the area—Capt. Joseph C. Lea picked up the mantle and started the Lea Cattle Company. Even J. J. Hagerman got into the game and bought cattle to graze upon Chisum's old land, which he then owned, even though he knew little about cattle.

Roswell was not just known for cows back then; it was also a major producer of fruits, vegetables, and alfalfa, although Roswell was best known for its apple orchards. An abundance of them were planted after the artesian water was discovered in the early 1890s. Before that, James Chisum planted the first apple trees on South Spring River Ranch in the later half of the 1870s. By the time J. J. Hagerman acquired the ranch, Chisum's trees had already matured, and soon more were planted. The Hagerman Orchard on the old Chisum ranch was called by residents of the time the "largest apple orchard in the world." Whether it actually was or not is surely up for debate, but at 500 acres, it was very large.

One of the more prominent ranches in the Roswell area was the Slaughter Ranch. In these two c. 1902–1907 photographs is the Slaughter Ranch and its star bull, Sir Bredwell, one of the finest Hereford bulls in the world. The Slaughter Ranch came to Roswell via wealthy Texas colonel C. C. Slaughter and son George Slaughter when Colonel Slaughter purchased 1,000 acres of ranch land east of Roswell, which he later expanded to 2,000 acres. (Both courtesy HSSNM: above, No. 1618B; below, No. 1618A.)

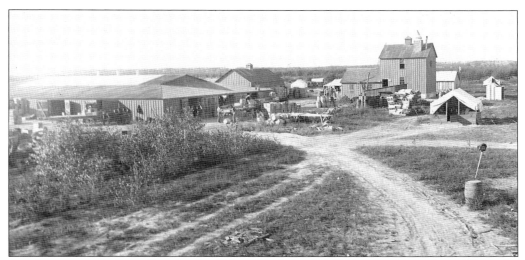
Another prominent Roswell outfit, the Clifton Chisholm Alfalfa Farm, is shown above (Chisholm should not be confused with Chisum, although they often are). Alfalfa is one of the steadiest crops in Southeastern New Mexico. (Courtesy HSSNM, No. 953.)

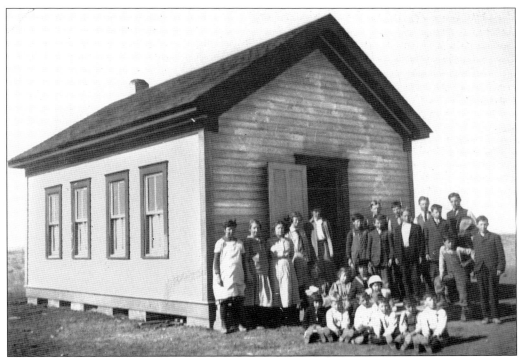
Another prominent agricultural area of Roswell is East Grand Plains; unfortunately, not many photographs seem to exist outside of private collections. Shown above is the East Grand Plains School in an undated photograph. (Courtesy HSSNM, No. 4806.)

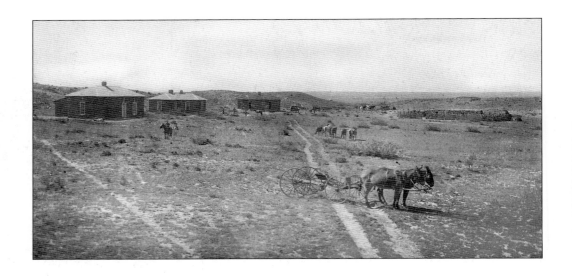

Although the headquarters of the Bar V Ranch (above) are situated in the current vicinity of De Baca County, it used to be part of Chaves County and was known, as so many ranches were then, as a "Roswell outfit." The Bar V (—V) Ranch, first owned by J. J. Cox, was formed out of a marriage of sorts with a neighboring cattle outfit across the Pecos River, called the Cass Land and Cattle Company and owned by J. D. Cooley, W. G. Urton, Lee Easley, and G. R. Urton. The Bar V Ranch was located about 60 miles north of Roswell on Cedar Canyon. Below cowhands can be seen branding a cow at the Bar V Ranch. (Both courtesy HSSNM: above, No. 1923-5; below, No. 1923.)

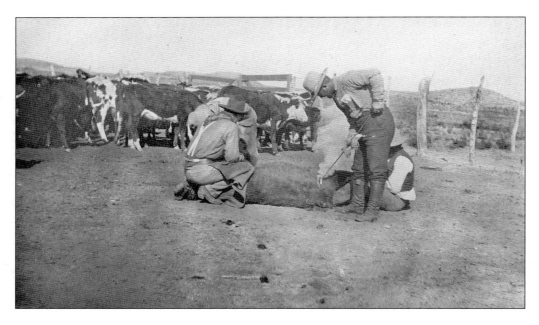

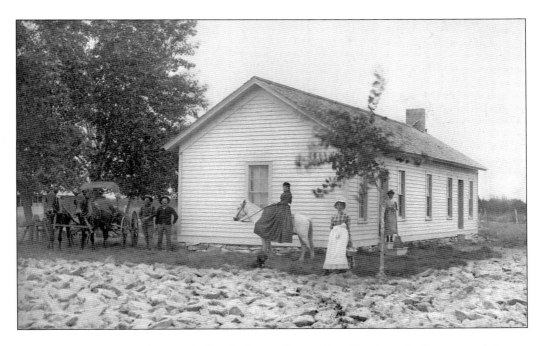

Shown here is the farmhouse of John W. Poe, a former sheriff of Lincoln County and deputy of Pat Garrett the night Garrett shot Billy the Kid in Fort Sumner. Poe lived in Roswell as a prominent banker with wife Sophie and had a farm outside of town. In the image above, Sophie Poe is shown carrying eggs in a basket. Berta Ballard is the woman on the horse, but the other woman and two men are unidentified. Below is a view of the Poe farm and what looks to be a crop of corn. Eventually the Poe farm was sold and became the LFD Stock Farm. (Both courtesy HSSNM: above, No. 496; below, No. 1615.)

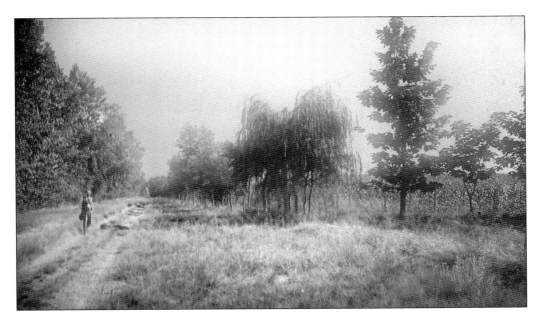

On this page are two views of the LFD Stock Farm. LFD was taken from the name of the Littlefield Cattle Company, which was formed in 1883. In addition to cattle, large apple orchards also existed on the LFD farm, as evidenced by the photograph below that features wagons loaded with apples on November 13, 1911. Today mostly cotton and alfalfa are grown there. Above is a view of a large weeping willow, which was a staple of the farm. The farm was run for many years by George Littlefield's nephew, J. P. White. (Both courtesy HSSNM: above, No. 1070; below, No. 3537C.)

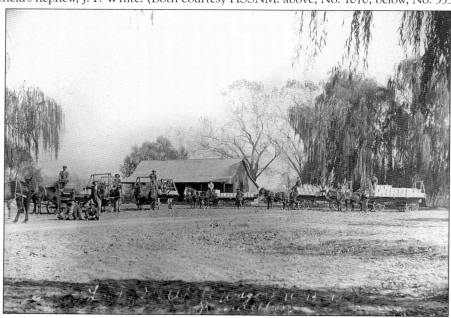

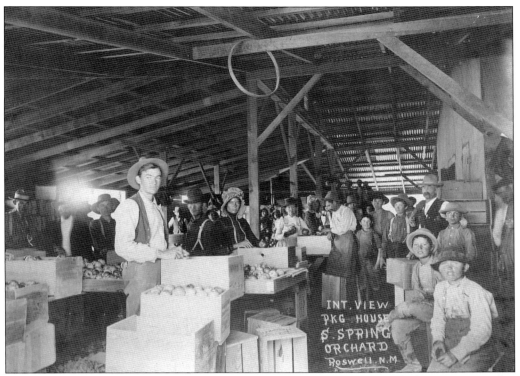

On February 8, 1933, a terrible freeze killed most of Roswell's apple orchards, leaving many of its current residents curious as to what the huge orchards, which they heard the old-timers speak of so often, looked like. Below is a view of an unspecified Roswell orchard, sporting an abundance of apples falling off the numerous trees. So many pounds of apples were picked in Roswell that they were transported by the millions via railroad cars to other markets. Above is the apple-packing house at the South Spring Orchard, owned by J. J. Hagerman. (Both courtesy HSSNM: above, No. 5242; below, No. 2851.)

The J. J. Hagerman Ranch south of Roswell, like John Chisum's old South Spring River Ranch on which it was located, was a high point of the Pecos Valley. On the huge 6,746-acre ranch was the elegant three-story Hagerman mansion, the 500-acre apple orchard, cattle, and its own railroad stop, at which J. J. Hagerman's private train car often rested. For a time, J. J. Hagerman tried his hand at cattle, perhaps for tradition's sake being located on Chisum's old property, but in the end, he found it not very profitable. A few of Hagerman's cattle graze in the c. 1900 image above. Below is a lush garden also located on the ranch in 1914. (Both courtesy HSSNM: above, No. 541B; below, No. 541.)

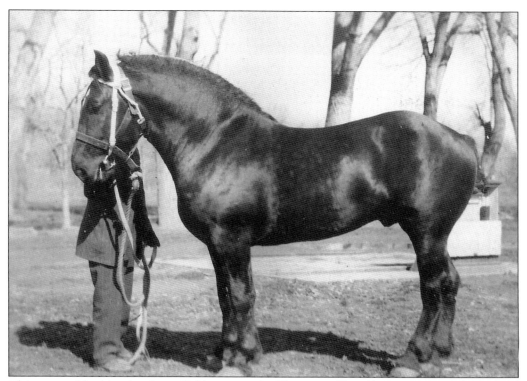

This unusual-looking but beautiful horse on the Hagerman Ranch was a registered imported Percheron stallion. (Courtesy Larkham Album 8, No. 4034.)

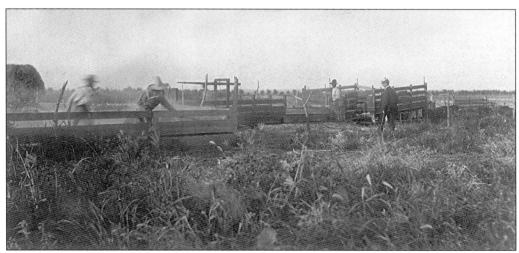

Above is a shot of some lively activity, stirring up some dust in one of the corrals on the Hagerman Ranch. (Courtesy HSSNM, No. 541C.)

Shown at left is a bushel of apples in the Hagerman Apple Orchard, sometimes still called the Chisum Orchard, in 1893. Below is a group of Hagerman apple pickers led by foreman J. E. Wallis (standing far right in foreground). Wallis came to Roswell in February 1904 and began working for J. J. Hagerman on his ranch that fall, and the next year, he was promoted to foreman. This photograph was taken in 1910, Wallis's last year to work for Hagerman before moving to Elida, New Mexico, and becoming a justice of the peace there. Not long after this picture was taken, the famous 500-acre orchard was broken up and sold as individual, smaller orchards. Raymond K. Wallis, son of J. E. Wallis, can also be seen in the back row (sixth from left). (Both courtesy HSSNM: left, No. 003C; below, No. 2046.)

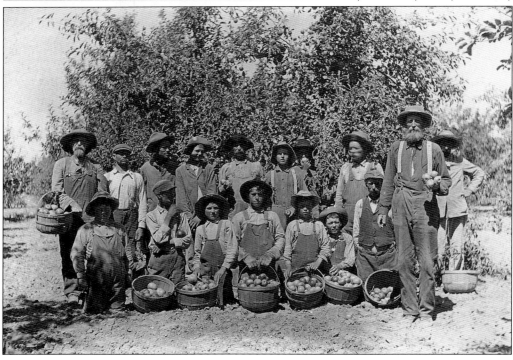

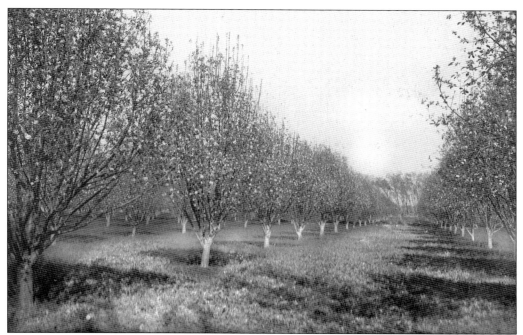

The first apple trees to be planted on the old Chisum Orchard were done by James Chisum, John Chisum's brother, in the late 1870s. After the discovery of artesian water, even more orchards were planted all over the Roswell area, such as the one photographed above. This 1904 image was often used as a popular Roswell postcard. (Courtesy HSSNM, No. 004.)

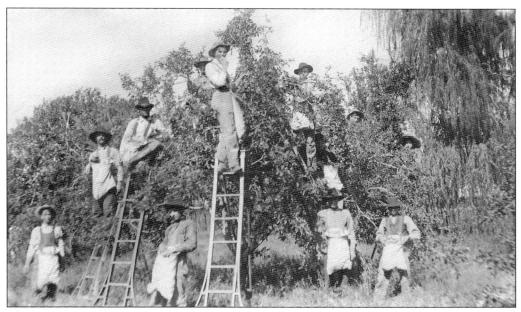

This image portrays a group of apple pickers in action in one of Roswell's many orchards. This photograph was likely taken at the Hagerman Orchard or the LFD Stock Farm. (Courtesy HSSNM, No. 3537E.)

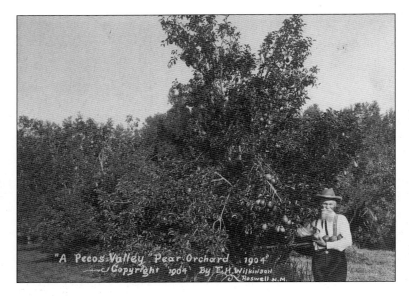

In addition to apple orchards, the Pecos Valley also had a few peach orchards, as seen in this 1904 photograph. (Courtesy HSSNM, No. 5243.)

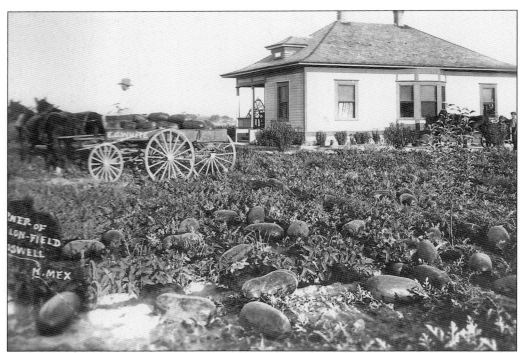

Roswellites even tried their hand at growing watermelons for a time; however, the melons did not transfer to other markets well due to refrigeration problems. (Courtesy HSSNM, No. 5575.)

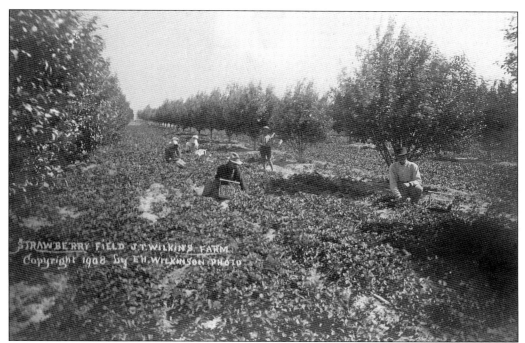

With the success of the apple orchards and the abundance of water, the people of the Pecos Valley attempted growing other crops. Above is a strawberry field in 1908, and below, farmers bank celery in 1907. One endeavor that was not successful was growing cantaloupes. They grew well, but they didn't transport easily. The cost to keep them cold on the way to other markets, with ice from the Diamond Ice Factory, was too high, thus the project was abandoned. A small quantity of melons was still produced for sale in the region, but no longer would they try to export them to the east. (Both courtesy HSSNM: above, No. 020B; below, No. 22B.)

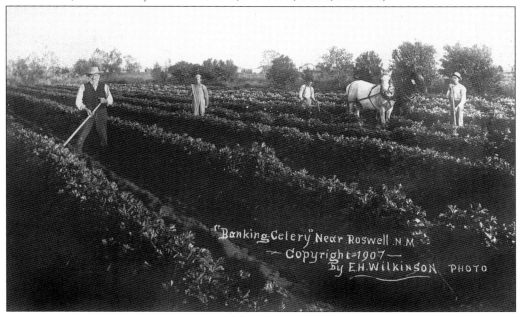

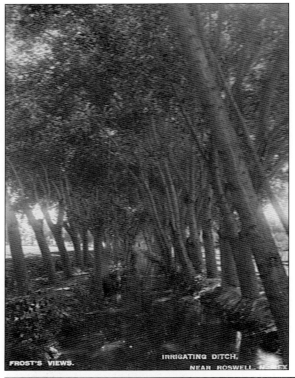

Irrigation had a large part in the cultivation of the Pecos Valley. At left is an unspecified tree-lined irrigation ditch in Roswell, and below is the well-known Northern Canal (sometimes referred to as the Hagerman Canal). The story of the Northern Canal begins with Pat Garrett and ends with J. J. Hagerman. Garrett had the idea to dig out a canal from his farmland 4 miles east of Roswell and divert water from several Roswell rivers. The trench for the canal was dug in 1889 and 1890. Along with Garrett, involved in the Pecos Valley Irrigation and Investment Company were Charles B. Eddy and Charles W. Green. When the company experienced financial difficulties, J. J. Hagerman bailed them out by taking over Garrett's interests in the company, and Garrett left the Roswell area soon thereafter. (Both courtesy HSSNM: left, No. 331; below, No. 1815.)

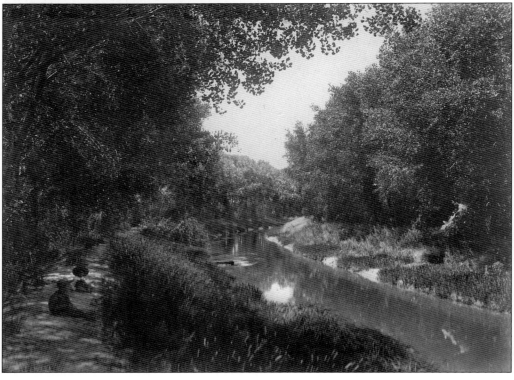

Five

Lower Peñasco and Elk

Examining a map of the boundaries of Chaves County is no doubt perplexing. While the county could easily encompass all of its major towns and settlements in a near-perfect square, its southwestern quadrant (sometimes called "the boot heel") extends to encompass the small mountain community of Elk and the Lower Rio Peñasco, which would look more at home in the neighboring forested counties of Otero or Lincoln.

The reasoning for Elk's placement in Chaves County is simple though. If it was in either of the other neighboring counties, the residents would have to pass through the tall and treacherous mountains to get to their county seat. So Elk and the Lower Peñasco were included within Chaves County's boundaries for an easy journey to Roswell. Of course it also helped that this meant the CA Bar Ranch and prominent Roswell banker and future mayor James F. Hinkle could stay within the county.

The story of Elk and the Lower Peñasco in Chaves County would not be complete without a brief history of both James F. Hinkle, who came to the west from Missouri in 1885, and the CA Bar Ranch in the area. Hinkle first arrived in the Lower Peñasco, then part of Lincoln County, when he helped to drive 800 head of cattle into the area from Toyah, Texas. Only a year later in 1886, at the young age of 23, Hinkle became the foreman and co-owner of the CA Bar Ranch in the Lower Peñasco area. Hinkle ran the ranch until 1901, when he sold it and its 40,000 head of cattle so that he could move to Roswell. In 1904, after the death of Capt. Joseph C. Lea, Hinkle would become one of the first mayors in Roswell and one of its most prominent bankers.

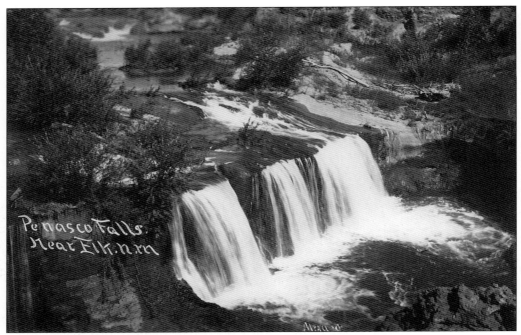

Above are some of the beautiful falls on the Rio Peñasco. The Rio Peñasco has clear, cool water year-round, and although some sections of the river may look small, it contains a decent amount of rainbow and brown trout. The Rio Peñasco also flows through Lincoln County, but the Lower Peñasco flows through Chaves County. (Courtesy HSSNM, No. 3846.)

Allie Powel Coleman and Nettie Hooter Powel pose in front of the Lower Peñasco Store and post office in 1910. The post office at the Lower Peñasco was the second post office in existence in Chaves County, having opened in 1884, before the county was even organized. The post office remained there until 1920. (Courtesy New Mexico State University Library, Archives and Special Collections.)

Shown at right are, from left to right, James F. Hinkle with his brother John Hinkle and good friends Dr. W. T. Joyner and Dr. Adair on horseback. Hinkle was manager of the CA Bar Ranch. In 1923, Hinkle was elected governor of New Mexico, and in 1935, he wrote the short but much respected book *Early Days of a Cowboy on the Pecos*. Hinkle was married to Lincoln County resident Lillie E. Roberts, whose uncle was sheriff of Lincoln at the time. In the photograph below, taken on July 4, 1908, Elk residents gather to watch their children in a hoop race out in the hills. (Right, courtesy HSSNM, No. 057H; below, courtesy New Mexico State University Library, Archives and Special Collections.)

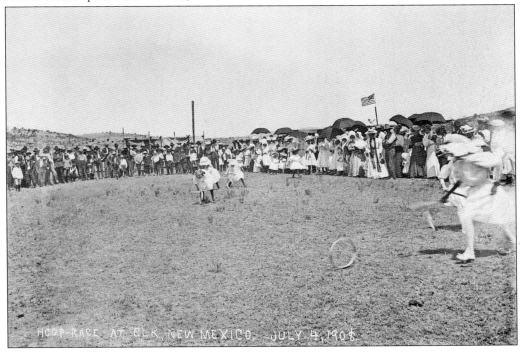

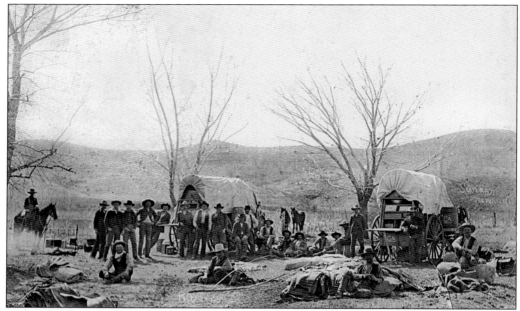

Shown above are the CA Bar cowboys of the Peñasco Cattle Company camping on the trail on Sunday, March 28, 1897. According to James F. Hinkle, the Peñasco Cattle Company had begun to close out as early as 1895, with the number of cattle raised and sold there declining every year. Once, on a cattle roundup in the mid-1890s, Hinkle says he counted more than 50,000 head of cattle out on the drive. The below photograph is undated and identified on the back as the "Peñasco Ranch," presumable meaning the CA Bar Ranch on the Peñasco. (Both courtesy HSSNM: above, No. 2082; below, No. 2081B.)

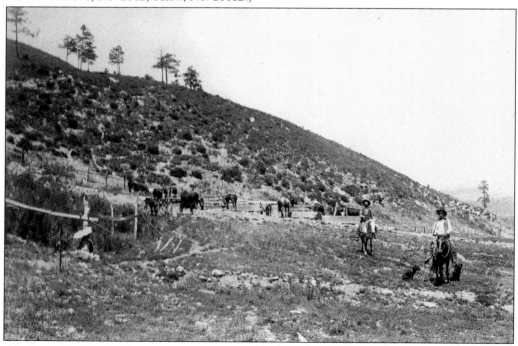

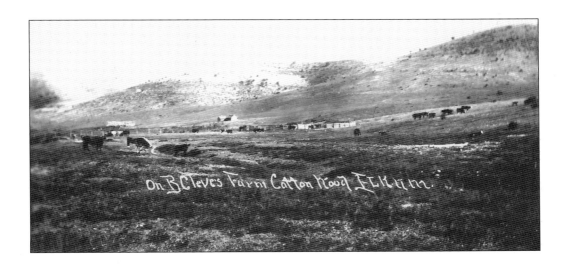

Shown above is the Bernard Cleve farm at Elk. Cleve was the main influence at Elk—the settlement was even named by one of the Cleve family members. Angie Hendrix Cleve chose the name for the post office there when it opened in 1894. There is also a place called Elk Canyon nearby where large elk roam, which likely contributed to the name. The Cleve farm not only had cattle but also had cotton and an apple orchard. Below is another scene from Elk of an unidentified ranch family. (Above, courtesy Larkham Album 8, No. 2923-72; below, courtesy New Mexico State University Library, Archives and Special Collections.)

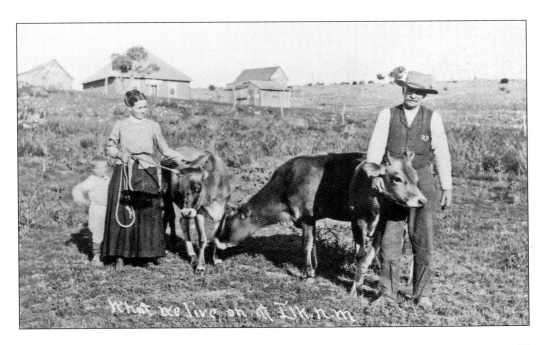

The CA Bar Ranch house is shown above in 1896 and below 10 years before in 1886. The year 1886 was remembered by many cattlemen of Southeastern New Mexico as the "great die up," since many cattle died from a drought. In 1885 and 1886, the winter snows and spring rains, which brought much water to the area, were nowhere to be found. The result was that when many dehydrated cattle finally found a water source, they would over-drink and become waterlogged and simply lie down and die. (Both courtesy HSSNM: above, No. 057L; below, No. 057A.)

After the horrible drought of 1886, many cattle outfits built windmills and drilled for wells so that their cattle would not go thirsty again. A few cow ponies of the CA Bar Ranch are shown in their corral at right. (Courtesy HSSNM, No. 057E.)

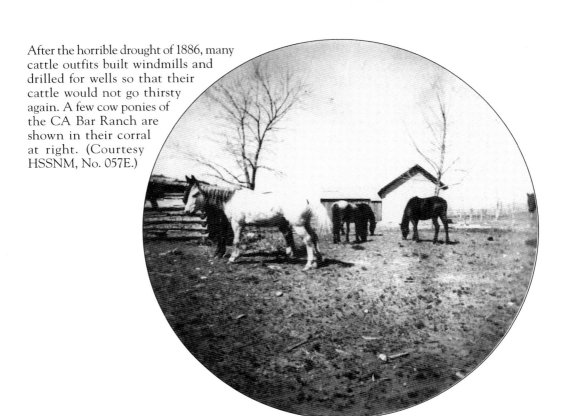

At left is the Elk General Store. Elk was originally called Yorktown, named for the nearby York Ranch. Some sources indicate Elk was settled by J. B. "Billy" Mathews, William Walker Paul, Thomas C. Tilston, and the Coe brothers, Frank, Al, and Austin. (Courtesy HSSNM, No. 057M.)

On this page are two views of the Elk General Store, the exterior above and the interior below. There are conflicting dates regarding Elk's settlement: some say it was settled in the 1870s, and other sources indicate it began with families from Texas in 1885. The Elk Post Office closed in 1958, and in recent years, the population of Elk has lowered drastically, as has that of the elk. (Both courtesy Larkham Album 8: above, No. 2894-2; below, No. 2894-3.)

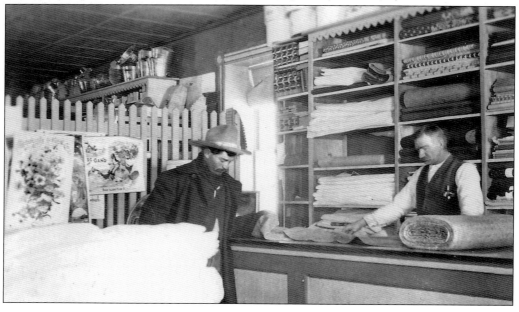

Six

PEARL OF THE PECOS

For a time, Roswell was known as the "Pearl of the Pecos," and Will Rogers once referred to it as "the prettiest little town in the west."

The 1890s were a time of change as the 20th century grew near. Trail drives were becoming a thing of the past, and the open range was becoming more and more fenced in. It was in this time of modern advancement that Roswell truly began to blossom into the town it would become in later years, even if cattle were still occasionally driven down Main Street. A defining factor of Roswell's beauty was its many trees, which were planted by Capt. Joseph C. Lea and the Chisums long before artesian water was discovered in the town. Of course, after the readily available water was discovered, even more trees were planted. As a result, Roswell became a city of trees and an oasis in the desert.

On the popular radio program *New Mexico in the Morning* hosted by Tim Keithley, the late Walter Dollahon, the writer behind the upcoming Lincoln County War drama *Lincoln Green*, said of his hometown, "Roswell has such a richer deeper history than just the [Roswell UFO incident]. I've said time and time again we have some great architecture and great old homes. The courthouse is a one-of-a-kind piece of architecture. And we've lost a lot of that. If we'd preserved some of that that had been torn down, Roswell would be more well known for its architecture and its history than the UFO incident."

Areas of interest in Roswell, some of which would disappear as early as the 1920s, were Haynes's Dream Park on North Spring River and the tree-lined streets. Some of the more interesting architecture in the town at the time included the Gilkeson Hotel, the post office, the Carnegie Library, and the new Chaves County Courthouse, built in 1911. Some of the buildings, such as the Carnegie Library and the Chaves County Courthouse, still stand in Roswell today, but many more unfortunately do not.

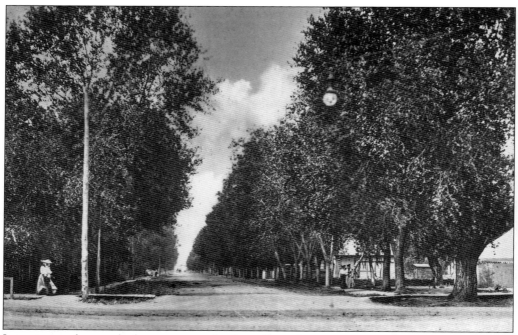

In an image that surely demonstrates why Roswell was known as a city of trees (many of which have since died or been cut down), two women walk along the sidewalk in this view of Fifth Street from the west. (Courtesy HSSNM, No. 159H.)

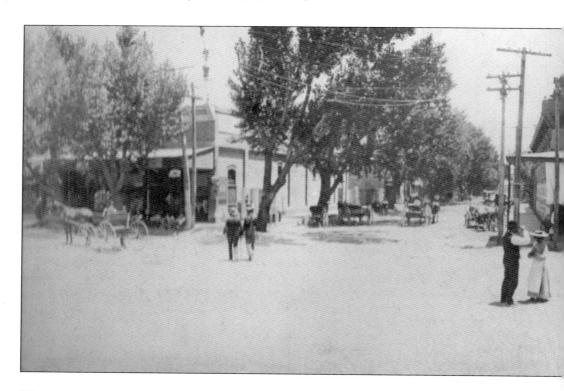

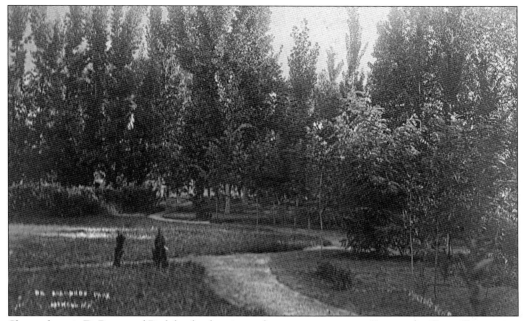

Shown here is DeBremond Park back when it was home to many trees. During the Great Depression in the 1930s, members of the Civilian Conservation Corps built DeBremond Stadium, which served as Roswell's main sports arena until the Wool Bowl was built many years later. (Courtesy HSSNM, No. 159L.)

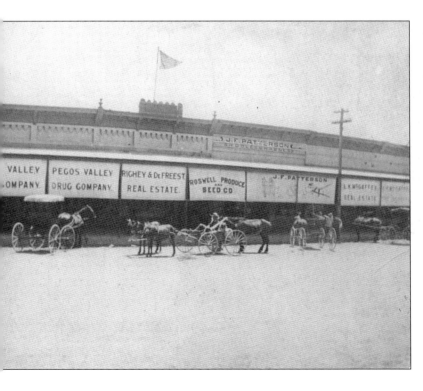

This panoramic photograph taken between 1899 and 1900 looks east from the intersection of Second and Main Streets in Roswell. Among the businesses seen on Main Street are Pecos Valley Drug Company; Richey and DeFreest Real Estate; Roswell Produce and Seed Company; J. F. Patterson Saddles and Harness; and L. K. McGaffey Real Estate. (Courtesy HSSNM, No. 314.)

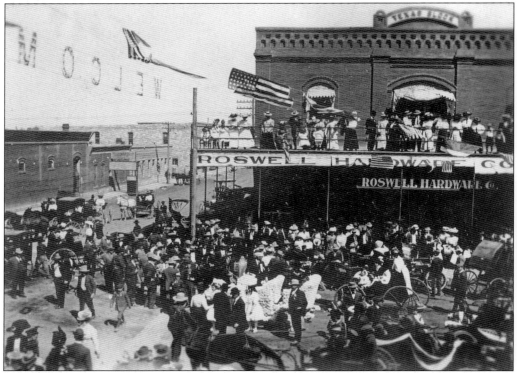

The photograph above displays a large gathering at the corner of Third and Main Streets. The early 1900s were a time of improvement in Roswell, while its population was experiencing large growth. One of the biggest complaints among citizens was the condition of Main Street, and the town board received a petition requesting that Main Street be improved. Eventually sidewalks were put in, and the streets were finally paved. (Courtesy HSSNM, No. 5619.)

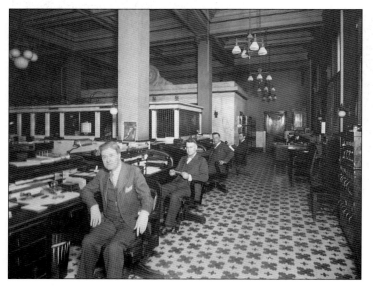

Shown here is the interior of the First National Bank in Roswell around 1931. An interesting story concerning the bank took place in 1936, when rumors circulated about the bank being robbed on a particular day. Many Roswell men took vantage points from several second-story windows in buildings opposite the bank that day, although it was never robbed as rumored. James F. Hinkle was president at the time. (Courtesy HSSNM, No. 243.)

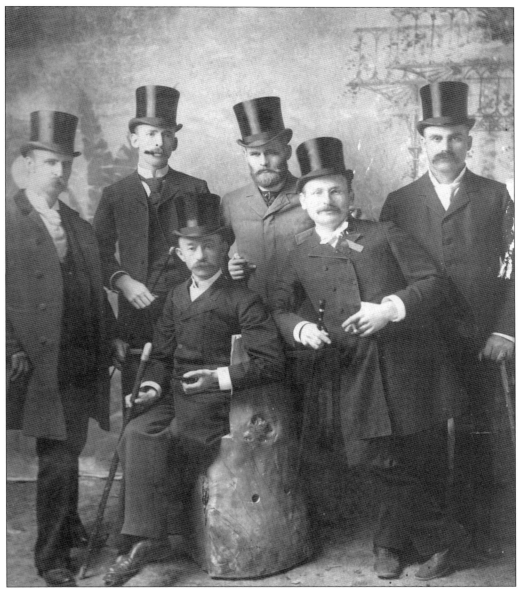

Posed in suits and top hats are some of Roswell's most esteemed businessmen. From left to right are (standing) G. A. Richardson, J. P. Church, Will Prager, E. A. Cahoon, and A. M. Robertson; (seated) Nathan Jaffa. Their notable achievements are as follows: Nathan Jaffa and Will Prager were the owners of Jaffa, Prager, and Company, the first department store in Roswell; J. P. Church was an esteemed businessman and husband to Amelia Bolton Church, who was instrumental in starting the Roswell Museum; E. A. Cahoon came from Albuquerque to establish the first bank in Roswell with John W. Poe; and G. A. Richardson was a judge in Roswell. (Courtesy HSSNM, No. 362.)

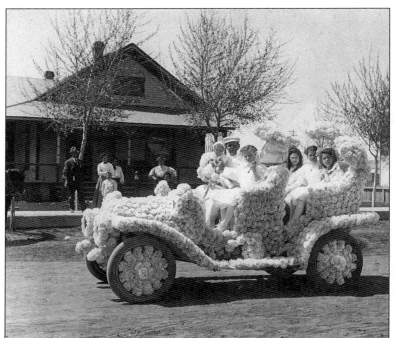

At left is a car decorated entirely in flowers for a 1904 parade. Cars were not entirely welcome on Main Street in Roswell's early days, as they often spooked the horses when they went by. In the early 1900s, there were still many more horses than there were cars on Main Street. (Courtesy HSSNM, No. 1904.)

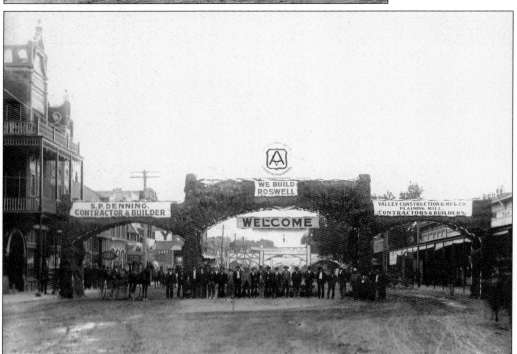

Above is a builder's fair at the beginning of the 1900s in Roswell. The banners seen hanging across the street are "United Brotherhood Carpenters and Joiners" (center Masonic symbol), "S. P. Denning Contractor & Builder" (left), and "Valley Construction and Mfg. Co. Plaining Mill, Contractors & Builders" (right). (Courtesy HSSNM, No. 1190.)

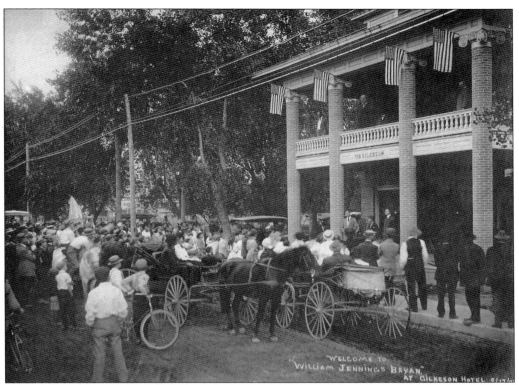

William Jennings Bryan, a well-known Chautauqua lecturer and three-time Democratic presidential candidate, speaks to a large crowd at the Gilkeson Hotel on September 17, 1909, in the above photograph. The Gilkeson Hotel opened in Roswell on November 15, 1906, and was located at Third Street and Richardson Avenue. The hotel was greeted enthusiastically by residents and travellers alike, because Roswell's previous modern hotel, the Shelby, built only five years before, had already closed down. In 1908, an annex was added onto the building, bringing the Gilkeson's total number of rooms to 40. The hotel also had a luxurious dining room, which can be seen below. (Both courtesy HSSNM: above, No. 473; below, No. 344A.)

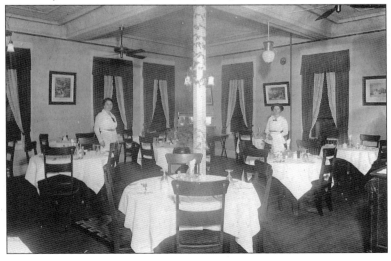

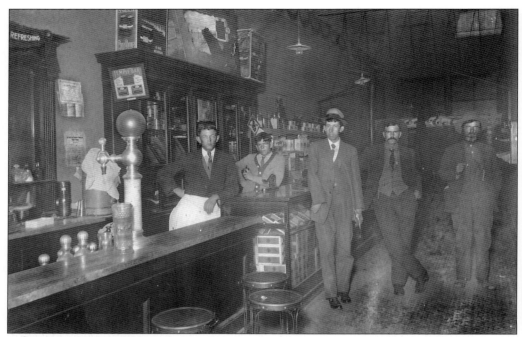

A soda jerk and several customers pose in this December 1907 photograph in Welter's Confectionery at 402 North Main Street. (Courtesy HSSNM, No. 500A.)

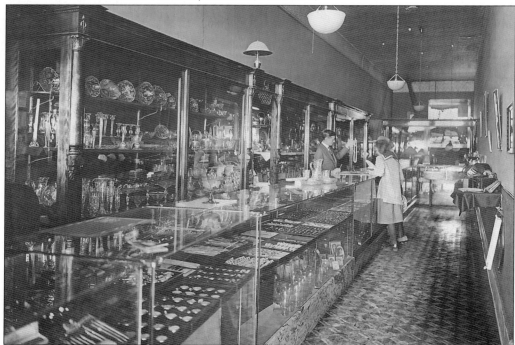

Hugh M. Huff Sr. holds up a necklace for a potential customer at Huff's Jewelry Store at 222 North Main Street. Huff was a lifelong jeweler who moved to Roswell in 1909 and considered it to be "the greatest place on earth to live." (Courtesy HSSNM, No. 501B.)

Two unidentified clerks pose for this photograph at Welter's Handmade Boot Shop in August 1914. (Courtesy HSSNM, No. 500B.)

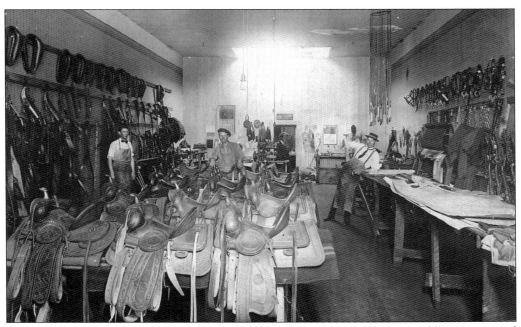

The interior of Welter's Saddle Shop, along with a few workers and many saddles, is pictured above in August 1914. (Courtesy HSSNM, No. 500C.)

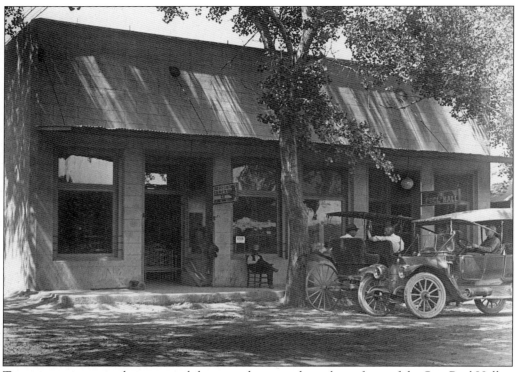

Two men converse in their automobile as another man drives by in front of the Star Pool Hall at 123 North Main Street in 1915. (Courtesy HSSNM, No. 224.)

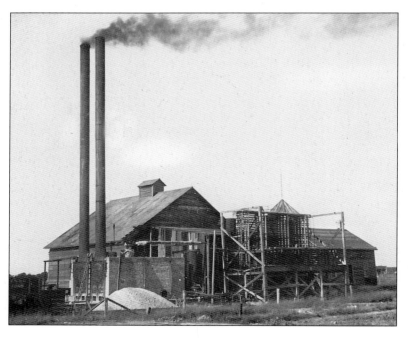

Before the Diamond Ice Factory (at left) was built, Roswell got ice from Eddy, where an ice plant was located. James Gilmore and Dave Scott traveled to Eddy in the cold of winter so that when they transported the ice back to Roswell, it would not melt. By 1899, the Diamond Ice Factory was up and running, producing ice for 75¢ per 100 pounds. (Courtesy HSSNM, No. 692.)

Like the rest of Southeastern New Mexico, snow in Roswell is fairly rare compared to other parts of the United States. In this rare photograph of Roswell, the intersection of North Main and Seventh Streets is pictured during a snowfall. (Courtesy HSSNM, No. 159.)

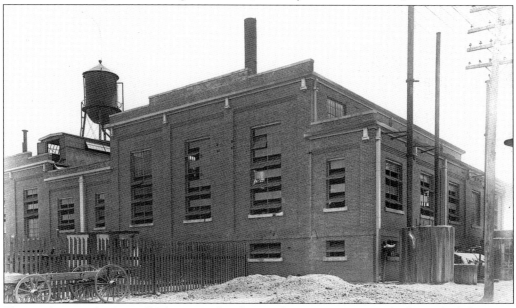
Shown above is the Roswell Electric Light Plant and Power Company, which was built between 1899 and 1900. Before the Roswell Electric Light Plant and Power Company came into being, the New Mexico Incandescent Light Company was responsible—albeit on a much smaller scale—for lighting Roswell. (Courtesy HSSNM, No. 172.)

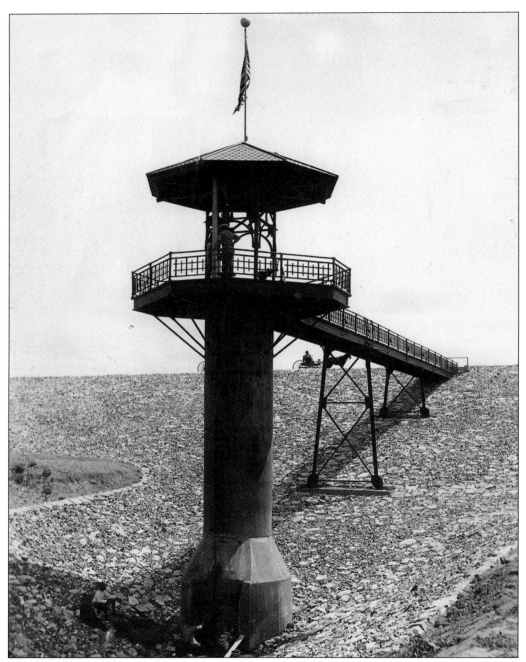

The Hondo Reservoir was an ambitious project in the Pecos Valley that began around 1888 and was constructed by private individuals up to 1890, when the project shut down; the federal government restarted it in 1904. Construction on the reservoir began again in 1906 and was completed by 1907. Unfortunately, the project for the most part was a failure, as was a similar project at Macho Draw north of Roswell in the 1890s. The projects failed due to insufficient water supply as well as the fact that much of the water captured in the reservoir seeped down into underground formations. (Courtesy HSSNM, No. 029B.)

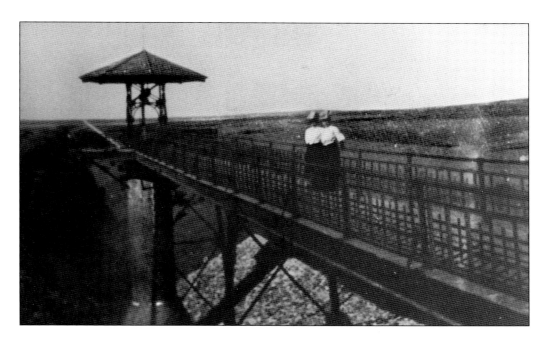

The Hondo Reservoir was located 12 miles southwest of Roswell in a natural basin supplied by the Hondo River, which flowed from the White Mountains in Lincoln County. The earthen dams built by the government can be seen below lined with stone. The shoreline of the dam was somewhat irregular and was about 9 miles in circumference. Hattie and Louise Cobean stand on the bridge at the Hondo Reservoir in the 1906 photograph above. (Both courtesy HSSNM: above, No. 029A; below, No. 029C.)

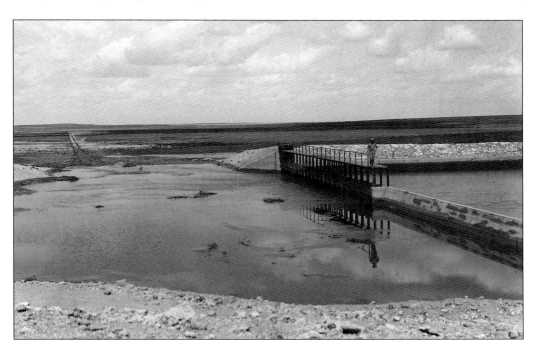

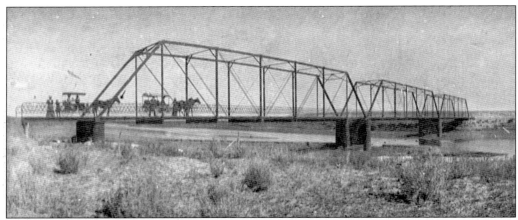

The Pecos River Bridge (above), which was completed in 1902, was built by the Midland Bridge Company using seven 19-foot panels totaling 133 feet to construct the bridge east of Roswell. In later years, a new bridge was built, but portions of the bridge still exist at the New Mexico Farm and Ranch Heritage Museum in Las Cruces. (Courtesy HSSNM, No. 2193.)

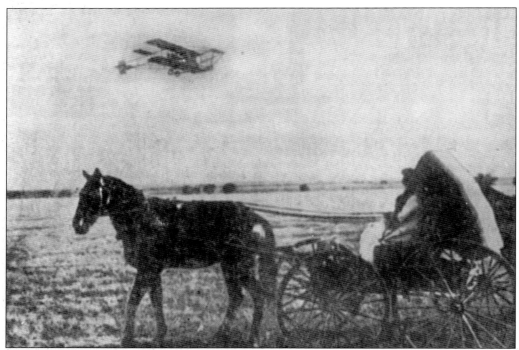

The onset of the modern era and the Old West are juxtaposed in this interesting 1910 photograph, which shows a Curtiss biplane flying over an old horse and buggy, still a common mode of transportation at that time. The picture was taken outside of Roswell, and the plane was flown by Herman Wetzig of Junction City, Kansas. (Courtesy HSSNM, No. 4894.)

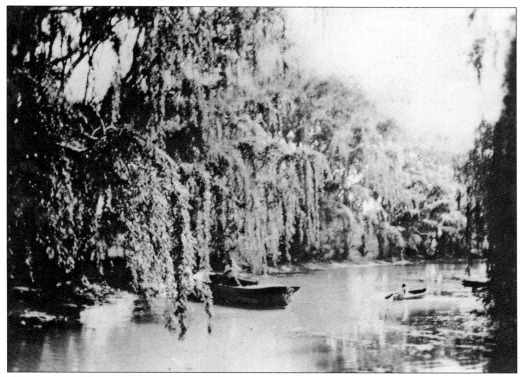

If one were told that the two photographs on this page were taken in Roswell, he or she would likely assume by its lush, marshy appearance that this is Roswell, Georgia, not Roswell, New Mexico. The beautiful locations portrayed in these two images, now long gone, were part of Haynes's Dream Park, located at the present site of Cahoon Park in Roswell. Capt. Charles W. Haynes was a sheriff of Chaves County who diverted water from the North Spring River to make a lush recreational area complete with gazebos, bathhouses, boats, and a swimming pool. Known officially as Haynes's Park and Natatorium, it was referred to as Haynes's Dream Park by skeptical Roswellites throughout construction. The park even had a powerboat called the M. S. *Katie* that took passengers for a 2-mile ride up the river. (Both courtesy HSSNM: above, No. 1902A; right, No. 287.)

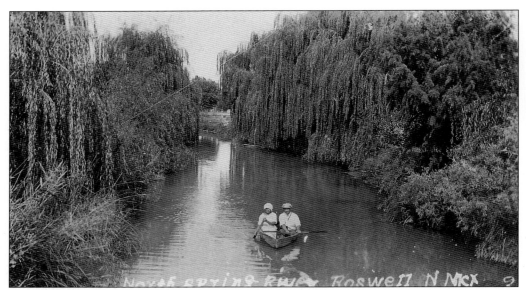

A couple enjoys the scenery at Haynes's Dream Park from their rowboat in the above photograph donated to the Historical Society for Southeast New Mexico by Walter Dollahon. The park disappeared with the North Spring River when it dried up in the 1920s. Without the water, things were never the same, and Haynes's Dream Park was no more. In the 1930s, it became the site of Cahoon Park, built by the Works Project Administration. (Courtesy HSSNM, No. 6284.)

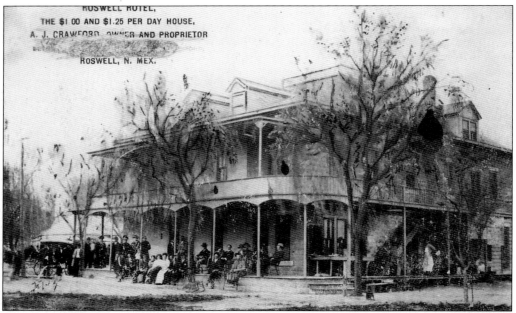

Shown above is an early Roswell Hotel owned by J. Crawford. Take note of the trees in the picture, which look to have had leaves and foliage painted onto them. It is presumable the picture was taken in the winter, when the trees were bare, and the leaves were painted on to make the location appear more attractive. (Courtesy HSSNM, No. 2051.)

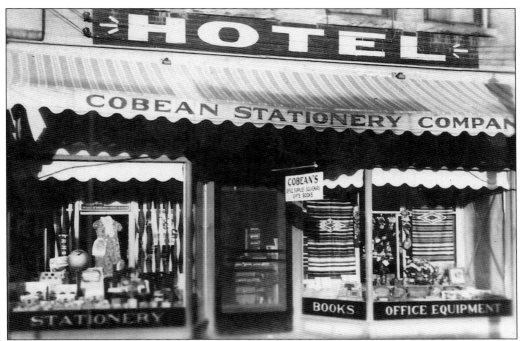

Shown above is the Cobean Stationery Company, currently the oldest operating bookstore in all of New Mexico. The store was opened in 1916 by the Cobean family at this location at 208 North Main Street but later moved to North Richardson Avenue, where it is still operated to this day by descendants of the Cobeans—and carries this very book. The Cobean Stationery Company can also be linked to Roswell's other oldest business, Roswell Seed, in that a member of the Cobean family, Hattie Cobean, married Walter Gill of Roswell Seed Company in 1931. Below is a photograph of an unidentified member of the Cobean family in Roswell. (Above, courtesy Larkham Album 1 No. 78; below, courtesy Cobean Stationery Company.)

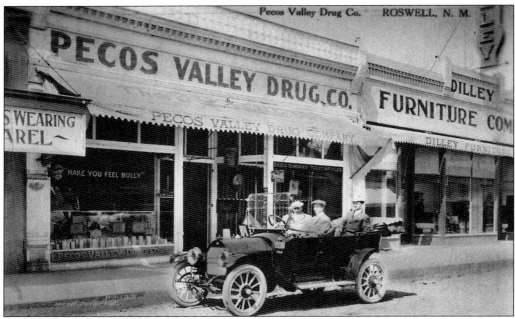

Motorists on Main Street pass by Pecos Valley Drug Company in the classic postcard above. Shown below, during an unknown demonstration of some sort, is the Carnegie Library, at Third Street and Richardson Avenue. The Carnegie Library was Roswell's first official library, thanks largely to the Roswell Woman's Club, who campaigned vigorously for a library beginning in 1897. Eventually philanthropist Andrew Carnegie, who helped build 2,800 libraries across America, gave $10,000 for construction of the library, while the Woman's Club secured the land and the books. Carnegie Library served Roswell until 1978, when a new public library was built. The building fortunately still stands and has been used as many other businesses since that time. (Both courtesy HSSNM: above, No. 1564-37; below, No. 1750B.)

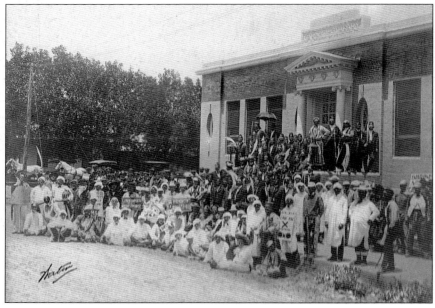

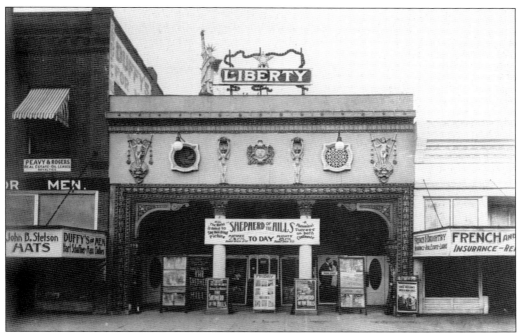

Above is the Liberty, one of Roswell's earliest theaters, located at 305 North Main Street. The motion picture being shown at the Liberty in this photograph is *The Shepherd of the Hills*, directed by Harold Bell Wright and released in 1919. (Courtesy HSSNM, No. 2262A.)

Roswell's Police Department of the 1930s is pictured here, from left to right, as follows: Pat O'Neal, health officer; E. J. House Jr., traffic officer; E. J. House Sr.; Virgil McCray; Perry Bean; Sam McCue; T. U. Alford, chief of police; R. L. Bradley, Roswell mayor; Rue Chrisman, fire chief; Walter Thornton, captain; I. J. Ballard, lieutenant; Frank McDaniel; Buck Martin; and Aubry Koonce. (Courtesy HSSNM, No. 4344.)

On January 6, 1912, New Mexico finally achieved statehood. Believe it or not, instead of New Mexico the state name had been proposed in 1888 as Montezuma or Acoma, in order to avoid any confusion with the country of Mexico. Roswellites read about their impending statehood in the *Roswell Morning News* on August 21, 1911, to much surprise and enthusiasm. Thousands of Roswell residents gathered at the corner of Third and Main Streets to listen to speeches made by the mayor and other prominent citizens regarding the benefits of statehood. The old Chaves County Courthouse was torn down and a new, much larger structure—one of the largest and most beautiful courthouses in all of the Southwest—was constructed in 1911. The new courthouse can be seen in these two photographs, and above, an unidentified man climbs on the dome. (Both courtesy HSSNM: above, No. 1976; below, No. 5047.)

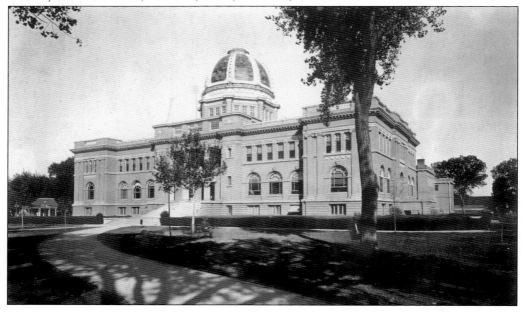

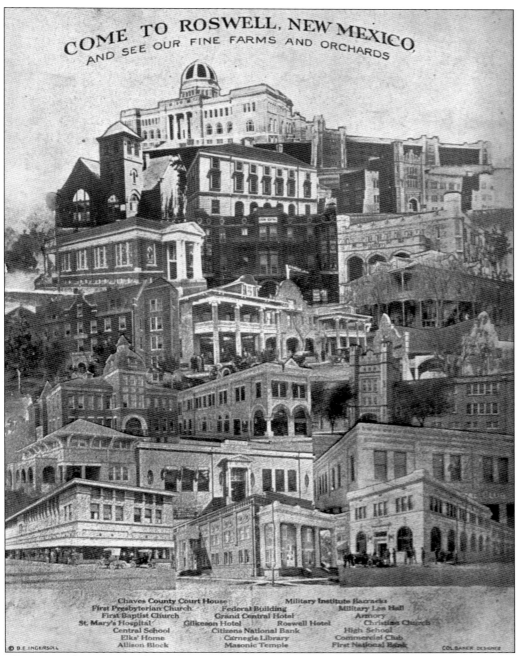

The postcard composite above depicts almost all of Roswell's most famous buildings and pieces of architecture, among them the First Presbyterian Church, First Baptist Church, St. Mary's Hospital, Central School, Elk's Home, Allison Block, Federal Building, Grand Central Hotel, Gilkeson Hotel, Roswell Hotel, Citizens National Bank, Carnegie Library, Masonic Temple, Military Institute Barracks, Lea Hall, New Mexico Military Institute Armory, Christian church, Roswell High School, Commercial Club, First National Bank, and Chaves County Courthouse. (Courtesy HSSNM, No. 3310.)

Above and below are two active views of Main Street in Roswell. The top view was taken from the east side of Third Street in 1911, and the below image shows a parade with floats, the exact year unknown. (Both courtesy HSSNM: above, No. 3553; below, No. 1987.)

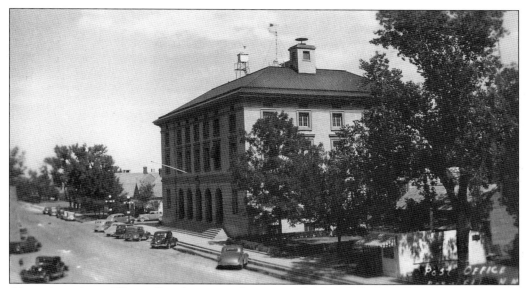

Above is a piece of Roswell architecture that was sadly demolished in 1971. The three-story building was constructed at 300 North Richardson Avenue as Roswell's post office and federal building in 1913. It was vacated in 1961 and used as the headquarters for Roswell Community College from 1963 to 1967. (Courtesy HSSNM, No. 1564-69.)

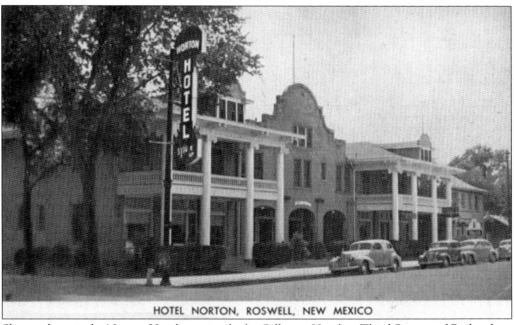

Shown above is the Norton Hotel, previously the Gilkeson Hotel, at Third Street and Richardson Avenue. Roy Norton purchased the Gilkeson Hotel in 1943, and the hotel stayed in operation until 1966, when it was demolished. Today the former hotel site is merely a parking lot. (Courtesy HSSNM, No. 1253.)

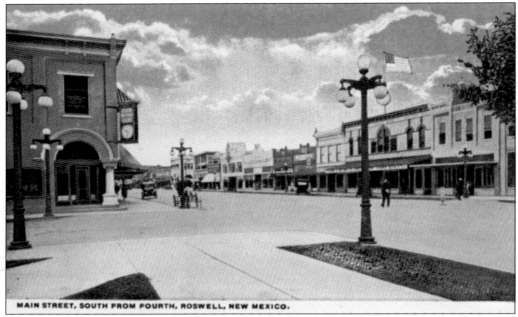

MAIN STREET, SOUTH FROM FOURTH, ROSWELL, NEW MEXICO.

Above is one final, fond look back at the old Roswell Main Street when both automobiles and horse-drawn carriages traversed Roswell's streets. Below is the old Gilder Hotel, today the current location of the First National Bank on East Fifth Street. The Gilder Hotel was built in 1908 with four floors and 25 rooms. In 1928, the hotel was bought by Guy Nickson and renamed the Nickson Hotel. In the 1930s, Charles and Ann Morrow Lindbergh stayed at the hotel for a night while on a trip to visit Dr. Robert H. Goddard. Hundreds of Roswellites gathered outside of the hotel to get a glimpse of the famous Lindberghs, much to the Lindberghs' chagrin. (Both courtesy HSSNM: above, No. 2720; below, No. 2740.)

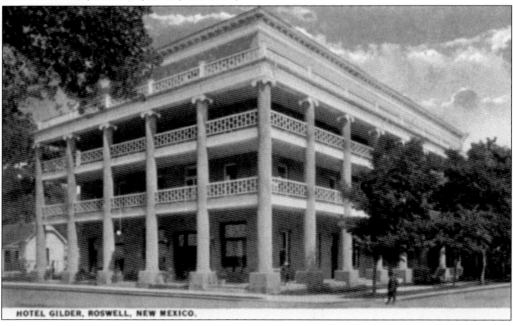

HOTEL GILDER, ROSWELL, NEW MEXICO.

Seven
Ghost Towns of Chaves County

During the 1890s, when towns such as Hagerman, Dexter, and Lake Arthur were springing up across the county, other small establishments, particularly along the railroad line, developed as well; however, most did not survive and have since become ghost towns. There were many such settlements in Chaves County, some of which consisted of little more than one building or outpost, among them Acme, Boaz, Frazier, Dunken, Vocant, Orchard Park, Chaves, Glen, Byried, Greenfield, Cumberland, and Trails End. Not much is known about many of these settlements, and even fewer pictures exist of the ones located in northern Chaves County.

Actually, most of them cannot even be called ghost towns, considering that little or no remains exist at the former settlements, many of which never even blossomed into full-blown towns. Some of the places often only consisted of a post office, a general store, and a few homes scattered about in their respective areas at the most. High Lonesome, for example, was merely a small store and gas station where families in the area went to get their mail. Bob Crosby, the famous rodeo performer, was one of the people to reside in the area.

Some of the more interesting former towns in Chaves County were Blackdom, a town populated entirely by African Americans, and Acme, a town named for a cement factory. Billowing black clouds could often be seen coming from the Acme plant's smokestacks, which combined with the sounds of clanging machinery and train whistles to give the town a distinctly industrial feel.

While little or no remains exist of the aforementioned towns, Greenfield and Cumberland still exist in a sense via the small town of Midway, named for its location between Roswell and Dexter.

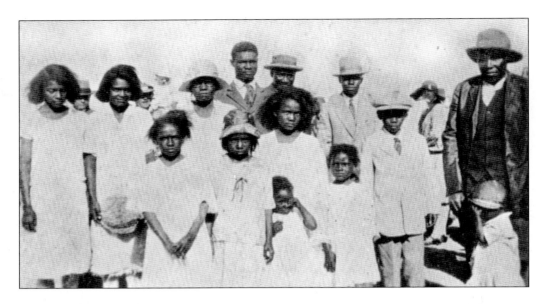

Among all of the abandoned towns in Chaves County, the most historic and well known is Blackdom. Located between Roswell and Artesia, west of Dexter and Hagerman, Blackdom was settled in the early 1900s. Frances Marion Boyer and wife Ella were the first to settle the town, fulfilling the dream of Boyer's father, Henry Boyer from Pullam, Georgia, who had seen the area many years before and dreamed of starting a community there. Above is a photograph, estimated between 1909 and 1912, of a Sunday school class from the local church, and below is the homestead of David Proffit. (Both courtesy Larkham Album 8: above, No. 4004-4; below, No. 4004-1.)

Blackdom consisted mostly of homesteads and farms by African Americans but also had a post office, general store, and Baptist church, which also served as a schoolhouse. Nearly 1,500 acres of land was cultivated by the families there. Above is the homestead of Loney K. Wagoner around the 1920s, and the boy in the photograph is likely Max Odell Wagoner. (Courtesy HSSNM.)

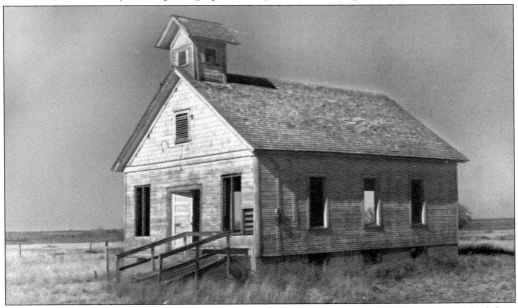

Shown above is the Baptist church in Blackdom, which also served as a schoolhouse. Blackdom was abandoned only 10 years after officially being platted in 1920 due to problems with water, namely droughts of the dustbowl era and problems irrigating water from the Pecos River, which was fairly far away from the town. A historical marker was erected near the old town site in recent years. (Courtesy HSSNM, No. 764.)

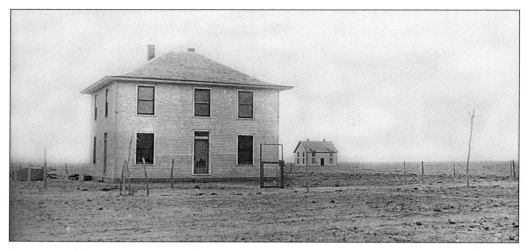

Cumberland, located a short distance south of Roswell, began as home to a small Presbyterian college. Before the college came into existence, there was a post office beginning in 1907. Cumberland consisted of several houses, a store, a church, and the college itself. The college never got off the ground, and the town was abandoned before the outbreak of World War I. Some of the houses and the hotel were later moved to Dexter. The large two-story home above belonged to Prof. W. F. Welty in 1910, and the post office in Cumberland, which can be seen with the store below, finally closed in 1933. (Above courtesy HSSNM, No. 849; below, courtesy Larkham Album 8 No. 2983-2.)

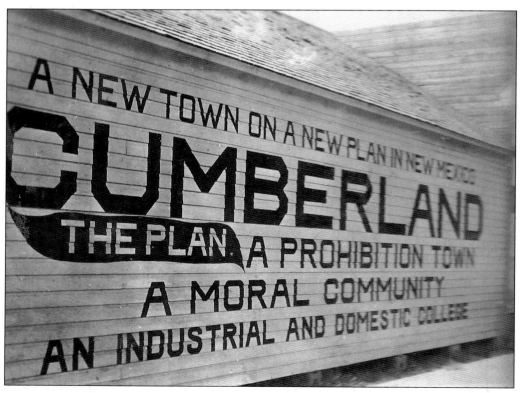

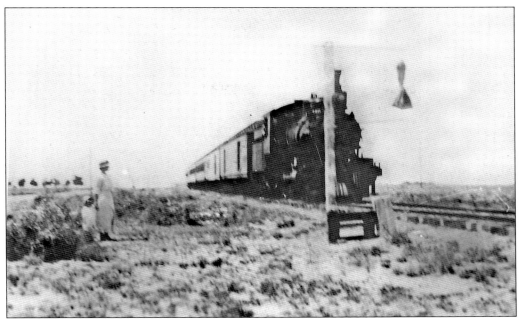

Shown above is the small railroad flag stop that served Cumberland around 1910. Below is a group of Dexter families, notably the Caziers, Caffals, and Robbins, on a hayride to Greenfield—another small town like Cumberland located between Roswell and Dexter—in May 1907. Greenfield was another stop along the railroad, in this case a hay-loading depot to ship alfalfa to other markets. The Greenfield Townsite Company officially filed upon the Greenfield land at the Chaves County Courthouse on April 16, 1908. A school district existed in Greenfield for several years, so the town arguably fared better than the nearby Cumberland. (Both courtesy Larkham Album 8: above, No. 2983-1; below, No. 784.)

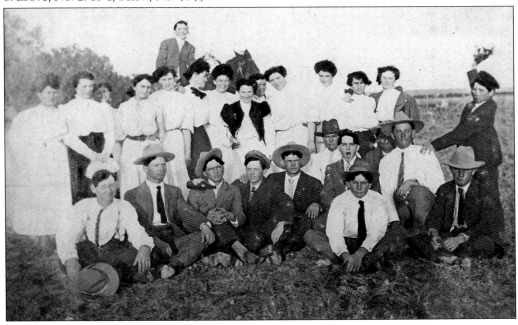

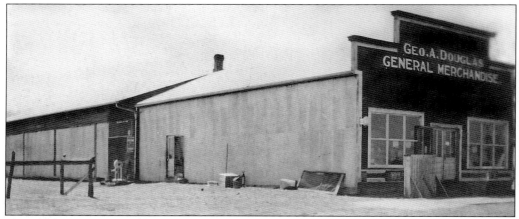

Shown above is the George A. Douglas General Mercantile in Greenfield. The post office in Greenfield, located in the back of this store, was built in 1911. The scales used to load the hay at the railroad depot were also located in this building. Today no remains exist of Greenfield, as all of the buildings there were either moved or torn down. (Courtesy Larkham Album 8 No. 4029.)

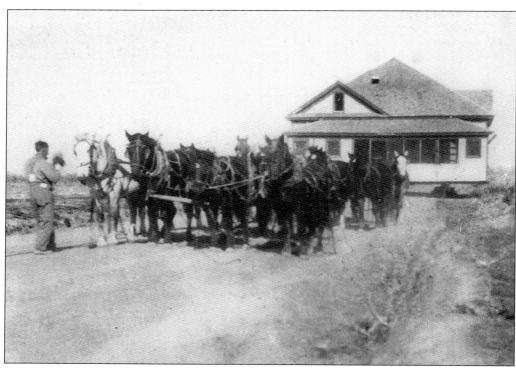

One home to be moved from Greenfield was the Dr. Stallard home (another source of this c. 1914 photograph identifies it as the Glen Wheeler home). Four teams of four horses each towed the 1,500-pound house with cable. The Armold Transfer Company from Roswell was contracted to move the home with the help of George Wade, Worthy Newsom, Ed Palmer, and W. E. Utterback. (Courtesy HSSNM, No. 4182.)

Just as there is no lake at Lake Arthur, ironically there is no orchard at Orchard Park—named by early settlers, the Christmans and Hortenstines, for the orchards they planted there (which never survived). Orchard Park was several miles south of Roswell along the railroad. The train never stopped at the settlement's small general store and post office; instead, the mailbag was thrown off the train as it went by and out-going mail was picked up via a hook on the train that snagged the mailbag off a post. Below is an oil well at Orchard Park, and at right is a group of men from the National Explorer Company at Orchard Park in 1920. In the 1940s, Orchard Park became a prisoner of war camp for captured German soldiers. (Both courtesy Larkham Album 1: right, No. 737; below, No. 2969-A.)

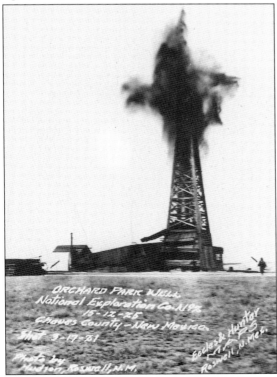

117

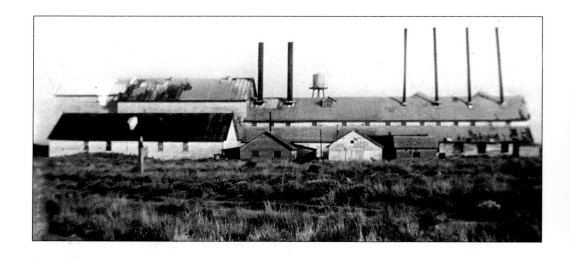

Acme was a relatively small community of 100 people about 20 miles northeast of Roswell that lasted for nearly 40 years. The town was named for the Acme Gypsum and Cement Company, which produced large amounts of cement from the readily available gypsum mined in the area. Due to the sizeable staff the plant employed, Acme became its own town with a post office, hotel, general store, company offices, and several four-room homes for the workers to live in. The plant opened in 1906 and was said to have 100 men in its employ, but only 30 men were on-hand at the plant full-time. Above and below are two different views of the cement plant. (Both courtesy HSSNM: above, No. 3112B; below, No. 1254.)

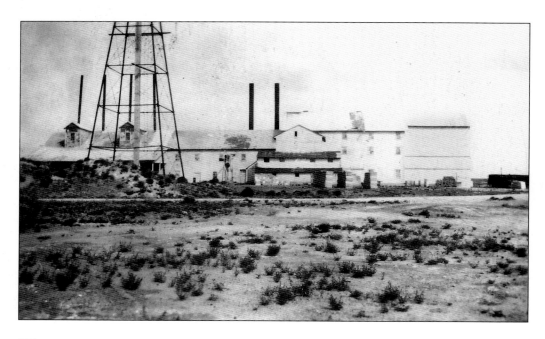

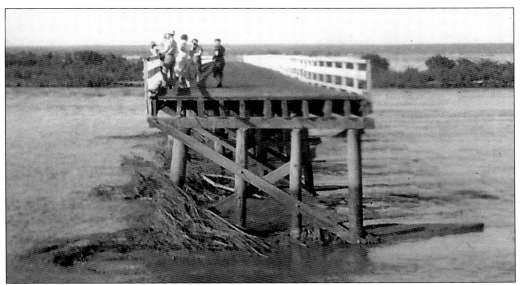

The town of Acme also had a railroad depot in its vicinity. The railroad bridge across the Pecos River to Acme, presumably washed out by a flood in this image, is shown above. Because water in Acme had too much gypsum, it had to be transported to the settlement from Portales, and one story relays how a drunk driver once crashed into the town water tower. The Acme Gypsum and Cement Company closed down some time in the mid-1930s, and the post office followed in 1946. Three Acme men pose in the c. 1922 image below. From left to right are N. H. Kight, D. T. Neill, and Noel Irby. (Both courtesy HSSNM: above, No. 1473A2; below, No. 3113.)

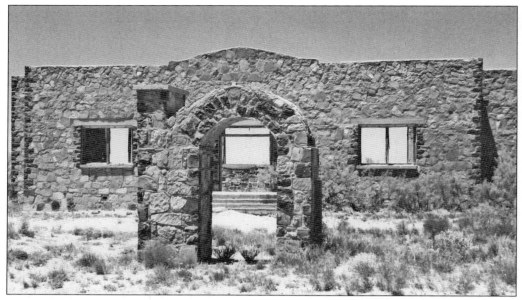

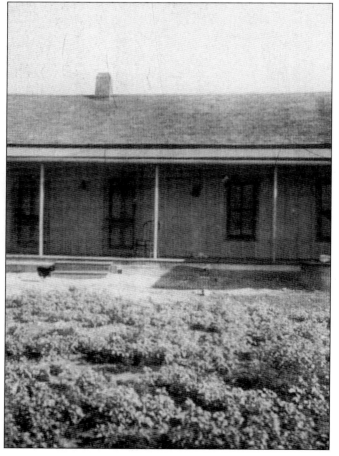

Of all the settlements mentioned in this chapter, one of the only ones with noteworthy remains is Frazier. Frazier began as a schoolhouse in the vicinity of Acme, the ruins of which are seen on this page. Frazier was named after Lake J. Frazier of Roswell, who ensured a new schoolhouse was built after the old Acme schoolhouse was demolished. (Courtesy Ken Case.)

Elkins, about 28 miles northeast of Roswell, is another small, abandoned ranching community that consisted of a few ranches, a schoolhouse, a post office, and a general store. The house at left was transported in pieces via train to Elkins from Oklahoma by Frank and Mattie Carroll. The pair also transported their cattle, themselves, and their family all on the same train. (Courtesy HSSNM, No. 4160.)

Frank Carroll owned the Basket Store in Elkins, which was the same one he owned in Oklahoma Territory and had torn down, shipped to Elkins, and then rebuilt there. Although Carroll was not a pharmacist, he often prepared medicine for the area doctor to give his patients. Above, from left to right, are unidentified, Basil Benson Lassiter, Roy Carroll, unidentified, Frank Carroll, Cecil Carroll, and an unidentified boy between 1917 and 1918. The man at right is Bert Red Shannon at the White Lake Ranch in Elkins around 1928. Unlike many of the abandoned settlements in this chapter, the post office in Elkins reportedly operated up until the 1970s. (Both courtesy HSSNM.)

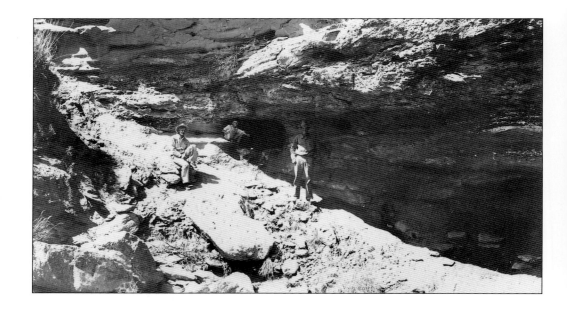

Billy the Kid Spring, as the name suggests, was a hideout of the famed New Mexico outlaw who rustled cattle and fought in the Lincoln County War. Billy the Kid Spring is not necessarily a ghost town, as it was never even a settlement. All it consisted of was a small dugout, the ruins of which appear below, and a spring hidden underneath the overhang cliff shown above. It is said that the sunlight never shines onto the spring, making it cool year-round. (Both courtesy HSSNM: above, No. 1489D; below, No. 1489E.)

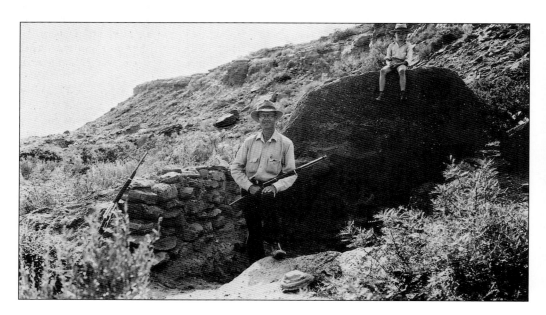

Eight

THE HISTORICAL SOCIETY FOR SOUTHEAST NEW MEXICO

The Historical Society for Southeast New Mexico has gone through many names and incarnations but began as the Old Settlers' Society for Chaves County in 1907. Many of the meetings took place at the old South Spring Ranch property, then owned by the Hagerman family. The first meeting of the society at the old Chisum ranch even had a few New Mexico celebrities in its midst, among them former Santa Fe Ring leader and lawyer Thomas B. Catron, then-Gov. Herbert J. Hagerman, and Judges G. A. Richardson and A. A. Freeman. The first president of the society was none other than J. P. White, whose home, unbeknownst to him, would one day become the society's main headquarters. James F. Hinkle was also a part of the society as secretary-treasurer.

Eventually the Old Settlers' Society evolved into the Chaves County Archaeological and Historical Society as a subsidiary of the state museum. In this incarnation, the society began putting on small exhibits at the current Roswell library. By 1937, the Roswell Museum was born of the Works Progress Administration, and the society took up residence there for a time. Eventually the Chaves County Historical Society split from the Roswell Museum (now known as the Roswell Museum and Art Center) and remained in a period of limbo for several years thereafter.

Finally in 1973, during the time of Roswell's centennial, a revival of the historical society seemed imminent, yet it was uncertain without the presence of a formal headquarters or museum to situate the society in. By July 1976, in time for the U.S. bicentennial, the heirs of J. P. and Lou White, both of whom had served as president of the society at one time or another, had donated the old White home at 200 North Lea Avenue in Roswell to serve as the Chaves County Historical Museum. And the rest, as they say, is history.

The Historical Society for Southeast New Mexico is still a nonprofit organization that exists solely from the support of its members and donors. Admission to the historical museum is free to the public—although donations and purchases from the gift shop are appreciated—and it is open seven days a week from 1:00 p.m. to 4:00 p.m. The Historical Center for Southeast New Mexico Museum is situated in the elegant J. P. White home at 200 North Lea Avenue in Roswell. It can easily be reached by turning west from Main Street onto Second Street. The museum is kept as a period home with styles and artifacts from around 1912 to 1920, and on the second floor are many different historical exhibits. Yearlong memberships to the society are available to everyone starting at $25. (Both courtesy HSSNM.)

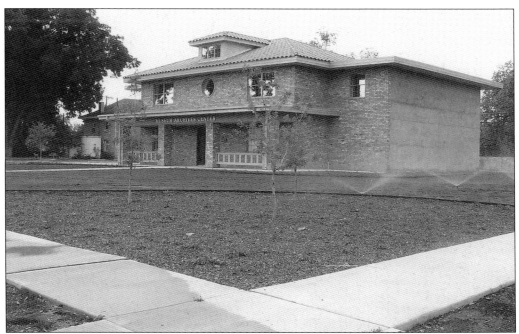

Due to the Historical Society for Southeast New Mexico's growing number of historical documents and photographs, which could no longer be housed on the third floor of the J. P. White home, an archives building was necessary. In 2005, thanks to a grant from the state, the construction of an archives building at 208 North Lea Avenue, next to the Historical Center for Southeast New Mexico Museum, was complete. Led by historian Elvis E. Fleming, along with other volunteers, the archives building is open from 1:00 p.m. to 4:00 p.m. on Monday, Wednesday, and Friday. The archives building, which also houses the office of the Historical Foundation for Southeast New Mexico, is available for private rentals for public functions. In the near future, the Historical Society for Southeast New Mexico hopes to build an all-new exhibit hall on the north side of the archives building that would house an array of historical exhibits from the community. (Both courtesy HSSNM.)

Bibliography

Banks, Phyllis Eileen. *Roaming Southern New Mexico*. Roswell, NM: Self-published, 2003.
Chaves County Historical Society. *Treasures of History: Historic Buildings in Chaves County 1870–1935*. Roswell, NM: Chaves County Historical Society, 1985.
Dexter Old Timers. *As We Remembered It*. Roswell, NM: Self-published, 1972.
Fleming, Elvis E., and Ernestine Chesser Williams. *Treasures of History II: Chaves County Vignettes*. Roswell, NM: Historical Society for Southeast New Mexico, 1991.
———.*Treasures of History III: Southeast New Mexico People, Places, and Events*. Roswell, NM: Historical Society for Southeast New Mexico, 1995.
Fleming, Elvis E. *Treasures of History IV: Historical Events of Chaves County, New Mexico*. Lincoln, NE: iUniverse, Inc., 2003.
Fleming, Elvis E., and Minor S. Huffman, ed. *Roundup on the Pecos*. Roswell, NM: Historical Society for Southeast New Mexico, 1978.
Hagerman Historical Society. *Meeting the Train: Hagerman, New Mexico, and Its Pioneers*. Hagerman, NM: Hagerman Historical Society, 1975.
Hinkle, James F. *Early Days of a Cowboy on the Pecos*. Roswell, NM: Self-published, 1937.
Julyan, Robert. *The Place Names of New Mexico*. Albuquerque, NM: University of New Mexico Press, 1996.
Larson, Carole. *Forgotten Frontier: The Story of Southeastern New Mexico*. Albuquerque, NM: University of New Mexico Press, 1993.
Michelson, Lynn. *Roswell: Your Travel Guide to the UFO Capital of the World!* Roswell, NM: Cleanan Press Inc., 2008.
Shinkle, James D. *Fifty Years of Roswell History: 1867–1917*. Roswell, NM: Hall-Poorbaugh Press, Inc., 1964.
———. *Reminiscences of Roswell Pioneers*. Roswell, NM: Self-published, 1966.
Torrez, Robert J. *UFOs Over Galisteo: And Other Stories of New Mexico's History*. Albuquerque, NM: University of New Mexico Press, 2004.

INDEX

Acme, 111, 118–120
artesian wells, 34–38, 40, 48, 65, 66, 87
Bar V Ranch, 68
Billy the Kid, 7, 69, 122
Billy the Kid Spring, 111, 122
Blackdom, 111–113
Bosque Grande, 8, 17
CA Bar Ranch, 79, 81, 82, 84, 85
Cahoon Park, 101
Carnegie Library, 87, 104
Cazier family, 37–39, 44, 46, 115
Chaves County Courthouse, 22, 87, 106, 107
Chihuahuita, 9, 11–13
Chisholm Alfalfa farm, 67
Chisum, John, 8, 9, 17, 18, 65, 72
Cleve, Bernard, 83, 86
Cobean Stationery Company, 103
Cumberland, 111, 114, 115
Dexter, 2, 7, 8, 37–47, 58
Dexter Cornet Band, 46
Dexter Lumber Company, 47
East Grand Plains, 67
Elk, 79, 80, 83, 85, 86
Elkins, 111, 120, 121
Fleming, Elvis E., 2, 4, 6, 14, 125
Frazier, 111, 120
Garrett, Pat, 7, 37, 69, 78
Gilder Hotel, 110
Gilkeson Hotel, 87, 93, 107, 109
Greenfield, 111, 115, 116
Hagerman, 2, 7, 8, 37, 48–59
Hagerman, Herbert J., 54, 56, 123
Hagerman Hotel, 57, 59
Hagerman, J. J., 18, 35, 37, 48–54, 65, 71, 72, 78
Hagerman Mansion, 53, 72
Hagerman Orchard, 2, 65, 71, 72, 74, 75
Haynes's Dream Park, 101, 102
Herrera, Alejo, 13
High Lonesome, 111
Hinkle, James F., 79, 81, 82, 84, 85, 90, 123
Historical Society for Southeast New Mexico, 6, 17, 123–125
Hondo Reservoir, 98, 99
Joyce-Pruit Company, 29, 57
Lake Arthur, 2, 7, 8, 37, 60–64
Lea, Capt. Joseph C., 7, 8, 14, 15, 17, 25, 32, 65, 79
LFD Stock Farm, 69, 70
Missouri Plaza, 9, 10
New Mexico Military Institute, 26, 27, 46
North Spring River, 16, 101, 102
Northern Canal, 42, 78
Norton Hotel, 109
Orchard Park, 111, 117
Pecos Bridge, 155
Pecos Valley Railroad, 35, 37, 40, 41, 46–49, 175, 179
Poe, John W., 30, 69, 91
Rio Peñasco, 79–82
Roswell, 2, 7–9, 19–36, 65–78, 87–110
Slaughter Ranch, 66
South Spring River Ranch, 18, 23, 53, 65, 72, 123
White, J. P., 17, 23, 70, 123, 124

127

www.arcadiapublishing.com

Discover books about the town where you grew up, the cities where your friends and families live, the town where your parents met, or even that retirement spot you've been dreaming about. Our Web site provides history lovers with exclusive deals, advanced notification about new titles, e-mail alerts of author events, and much more.

MADE IN THE USA

Arcadia Publishing, the leading local history publisher in the United States, is committed to making history accessible and meaningful through publishing books that celebrate and preserve the heritage of America's people and places. Consistent with our mission to preserve history on a local level, this book was printed in South Carolina on American-made paper and manufactured entirely in the United States.

This book carries the accredited Forest Stewardship Council (FSC) label and is printed on 100 percent FSC-certified paper. Products carrying the FSC label are independently certified to assure consumers that they come from forests that are managed to meet the social, economic, and ecological needs of present and future generations.

FSC
Mixed Sources
Product group from well-managed forests and other controlled sources

Cert no. SW-COC-001530
www.fsc.org
© 1996 Forest Stewardship Council

Find Your Place in History.